UNLEASHING THE *RAW POWER* OF

Adobe®
Camera Raw®

Mark Chen

AMHERST MEDIA, INC. ■ BUFFALO, NY

DEDICATION

To Mom and Dad, who helped me mature as a human and a photographer.

ACKNOWLEDGMENTS

Thanks to Kelly Willis and Dragos Dorobantu for lending me their cameras for testing. Special thanks to Abby Jeter and the good folks at Houston Camera Exchange for granting me access to their cameras for testing. Thanks also to the models who allowed me to use their images. Without you, photographers would be bored and broke.

Published by:
Amherst Media, Inc.
P.O. Box 586
Buffalo, N.Y. 14226
Fax: 716-874-4508
www.AmherstMedia.com

Publisher: Craig Alesse
Senior Editor/Production Manager: Michelle Perkins
Assistant Editor: Barbara A. Lynch-Johnt
Editorial Assistance from: Chris Gallant, Sally Jarzab, John S. Loder

ISBN-13: 978-1-60895-238-0
Library of Congress Control Number: 2010904513
Printed in Korea.
10 9 8 7 6 5 4 3 2 1

Check out Amherst Media's blogs at: http://portrait-photographer.blogspot.com/
http://weddingphotographer-amherstmedia.blogspot.com/

Table of Contents

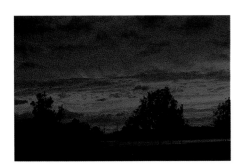

PHOTOGRAPH BY ROSIE ISRAEL.

ABOUT THE AUTHOR

Mark Chen is a photographer, Adobe Certified Photoshop Expert/Instructor, Photoshop trainer, and the owner of Mark Chen Photography based in Houston, Texas.

Chen's passion for photography started early, as a teenager in his native Taiwan. A pursuer of photographic artistry and a believer in imaging technology, Chen embraced digital photography with great enthusiasm. His computer science degree helped him feel at home with digital postproduction. Combining creativity, solid techniques, and a think-outside-the-box attitude, Chen has established himself as a creative wedding photographer whose album designs are sought after by clients with discerning tastes.

In addition to his studio operations, Chen teaches Photoshop at Houston Baptist University and Houston Community College and is touring the nation giving Photoshop training sessions. He is the author of *Creative Wedding Album Design with Adobe Photoshop* (also from Amherst Media). Look for information on Mark Chen's workshops and future books about Photoshop and photography, as well as his artistic endeavors that push the limit of what pixels can show us, at www.MarkChenPhotography.com.

At the beginning of the digital-imaging revolution, many photographers used their digital cameras as if they were film cameras with memory cards. Myths and jokes flourished. For example, photographers who used the LCD preview excessively were mocked for "chimping." Of course, as photographers made their way in the digital world, it turned out that chimping wasn't that bad—and it was the ones who did not use the previews wisely who ended up looking untrainable. Similarly, some photographers claimed they chose a certain brand of dSLR because it "produced better skin tones"—as if they were referring to characteristics of a film. The perception is fundamentally flawed; digital cameras do not provide skin tone, their settings do. And who controls the setting? Well, it better not be the untrainable film sympathizers!

But enough with the sarcasm. The point is this: digital cameras operate on totally different mechanisms than film cameras. While this initially confused photographers, we soon adapted. However, there seems to be one last frontier: shooting RAW files. Currently, not all photographers are routinely shooting RAW—and among the ones that do, many are not fully unleashing the potential of their RAW files.

WHY SHOOT RAW?

RAW files, on average, are seven times bigger than JPG files. They fill up your memory cards and hard drive much more quickly, and they take much longer to open. With all these inconveniences, why should you shoot RAW? Here's why: Inside every great photographer there is a tiny photographer who is . . . well, not so great. Shooting RAW can be your first line of defense against that tiny, lousy photographer. Clearly, shooting situations that are not fully under your control can be greatly benefited by shooting RAW. Event photography and sports photography come to mind—but tough conditions can toss hard balls at the photographer during any type of shoot. When this happens, RAW is on your side, helping you catch those hard balls.

I am a tennis fan, and a player, so I would love to show you an analogy from that sport. **Image 1-1** shows Mark Chen the tennis player holding a normal racket. **Image 1-2** is the same lousy player with a super-sized racket. You might have

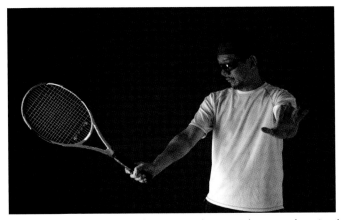

Image 1-1. Mark Chen the tennis player with a regular-sized racket.

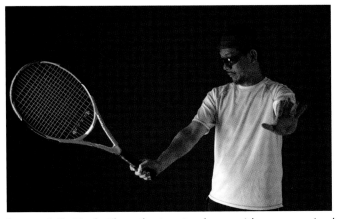

Image 1-2. Mark Chen the tennis player with a super-sized racket.

Image 1-3. A hi-fi component with just an on/off button.

Image 1-4. A hi-fi component with lots of sliders and knobs.

Image 1-5. A pre-seasoned hamburger patty.

Image 1-6. A juicy ribeye steak.

guessed it: shooting JPG is like swinging the small racket; shooting RAW gives you the larger racket. In other words, shooting RAW gives you a larger sweet spot.

Does this mean commercial and fashion shooters who tend to put conditions well under control (say, shooting in a studio) need RAW less? Here comes another analogy—this time from Mark Chen the audiophile. Imagine we have two hi-fi stereo components. One is covered with knobs and sliders; the other only has an on/off button. You guessed it! The button-covered model is RAW, the simple model is JPG. Shooting RAW provides much more room for tweaking; JPG is all hard-wired. Adjusting with sliders and knobs is a lot easier than adjusting with soldering irons and wire cutters.

A third RAW advantage—and the one literally associated with the name RAW—is the rawness of RAW. If images were beef, JPG would be a preseasoned hamburger patty; RAW would be a nice, juicy piece of USDA-graded ribeye, which has far more potential than the burger.

Some might argue the analogies are not entirely accurate—and criticisms are accepted! But did I get you excited? Would you like to find out how to unleash the raw power of RAW? If so, flip though these pages and follow along with the examples provided.

2. Things You Should Know About RAW

RAW: THE WHOLE-HEARTED TRUTH FROM A DIGITAL CAMERA

What makes a RAW file much more powerful than a JPG file? The preface to this book offered some analogies (if you're a habitual preface-skipper like me, now is the time to go back and read it), but the simple answer is that RAW gives you all the data the camera learned about whatever you photographed, whereas JPG gives you a much reduced version. To appreciate the difference, set your camera to simultaneously capture a RAW file and a JPG Fine (or High-Quality JPEG) file. Then, go photograph something. Load the RAW file and JPG file to your computer and compare the file sizes. You will find the RAW file is many times larger than the JPG file.

So why is RAW a lot bigger than JPG? Because RAW tells you the whole-hearted truth and JPG only gives you a small part of the truth. If RAW is as honest as an ideal politician, JPG better resembles the "real" Washington, D.C. If you are tired of hearing discounted truth, at least you can make your camera honest by setting it to shoot RAW!

In the chapters to come, you will learn how we can benefit from the wholehearted truth of RAW.

DIGITAL CAMERAS ARE NOT MADE EQUAL

While using RAW gives you the wholehearted truth from a digital camera, the actual quality of the RAW image depends on what the camera can deliver. Many factors contribute to a deterioration in image quality. The limitation on the number of pixels, the tendency to produce noise (which will be explained in detail later in this book), the surrounding temperature, the optical quality, and—yes—you as the cameraman (feminists are glad to be neglected here) can also reduce the final quality of the file. When you choose to shoot

RAW, however, at least one unnecessary and potentially negative factor is avoided: the in-camera JPG compression. All you need to do is change a setting to make a whole world of difference; all the other potential issues require money, money, and more money to improve.

Not all digital cameras can shoot RAW; while all the dSLRs can, many point-and-shoots can't. Therefore, for a professional, a dSLR is the obvious choice. If you are a serious amateur, you might want to think twice before you pay for that slim point-and-shoot camera Maria Sharapova sports in those tennis-themed commercials. Not only do those tiny cameras produce inferior image quality and have a longer shutter delay, they do not shoot RAW. The world of photography is full of tradeoffs. In this case, if you want to gain the quality, you have lose the convenience. But there is good news, too: the prices of dSLRs are continually dropping. As this book is written, entry-level dSLR's are only slightly more expensive than an average point-and-shoot—and a lot cheaper than many of the fancy point-and-shoot models.

Once you are equipped with a camera that can deliver RAW files, the door to the wonderful world of digital photography opens wide.

ADOBE CAMERA RAW

All those knobs and sliders mentioned in the preface do not come with the RAW files themselves; it is the Adobe Camera Raw software that gives us all the functionality. Camera manufacturers provide their own RAW-file processing programs, but none of them has achieved much real popularity—perhaps because making cameras from electronic and mechanical parts is a very different process from designing computer programs with logics and codes.

I give a thumbs up to the camera manufacturers for all the improvements they have made to their cameras; after trying their software, though, I must give it a thumbs down.

At the time this book was written, Adobe Camera Raw was at version 5.5. That is what you will see in the demos through out this book. Fortunately, the differences between versions of Camera Raw are even less of an issue than for versions of Photoshop. I can't imagine any revolutionary development in future versions, so you should be able to use these techniques with whatever version you happen to own.

THE WILD, WILD WEST OF RAW

So far, I have painted a rosy picture of RAW, but you should know that there is an ugly side of it, too. I am talking about the lack of any industry standard for the format—which leads to total chaos.

Each camera manufacturer uses a RAW extension of its own: NEF for Nikon; CR2 for Canon; and so on. On top of that, each camera model creates a different RAW format—even though the extension remains the same for the whole brand. The mere fact that the same file extension leads to different file formats is confusing enough—not to mention that every time a new camera model comes to the market, a new RAW format comes with it. If you have a RAW file from a brand-new camera model but your RAW file-processing software is not as new, an unpleasant "unrecognizable file format" message will pop up when you try to open the file. This happened to me when I bought my Nikon D2X when it was newly released. Since Adobe needs time to modify their Camera Raw software to work with the new format, I had to endure a month in the dark ages—a month with only JPG! It was like switching from filet mignon to beef jerky.

Adobe's way to handle this is to make the RAW-opening mechanism a plug-in. So Camera Raw is not actually a part of Bridge or Photoshop; it is a program that interprets the secret codes inside the files. Adobe needs the co-operation of the camera makers so they can decode the secret recipe of a certain RAW format. Once Adobe has the secret and a new Camera Raw update is ready, it is available as a free download on Adobe.com. The pace at which the camera makers churn out their new models keeps Adobe's engineers busy. How closely you need to keep track of the new plug-in versions depends on your line of work. An independent studio with a few cameras probably would not need to update excessively; an art director who needs to utilize images from many contributing photographers would have to watch it

closely. The good news: Adobe Updater will prompt you automatically when there is a new plug-in and takes care of the installation. The catch: newer RAW plug-ins will not install with older Photoshop versions.

DNG: THE DIGITAL NEGATIVE

There was no lack of effort to end this RAW lawlessness in the Wild West. In September of 2004, Adobe announced a royalty-free format (meaning using this format costs nothing) called DNG—short for "digital negative." This is a RAW format that does not include a manufacturer's proprietary encoding, so there is no problem opening it. Adobe's wish is to popularize this format by getting more camera makers on board. Let's sing it to John Lennon's "Imagine": "Imagine that all the RAW files, open like a breeze . . . yohoo . . ." Well, unfortunately, the years have passed and only a handful of camera models are using DNG. (So I think we should go on singing: "You may say that I'm a dreamer . . .")

Clearly, the camera makers have something else in mind that keeps them from using DNG. As a result, the war between royalists and separatists rages on.

Still, the lack of popularity of DNG among camera manufacturers does not render the format useless. There is a gadget called Adobe DNG Converter—a small, free-to-download program, usually paired up with Camera Raw, that provides lossless conversion from proprietary RAW files to DNG files.

Why would you want to convert RAW files to DNG? There are two good reasons. First, DNGs are smaller. You can normally cut the size by 20 percent. Nowadays that means you'll save about 100GB of hard drive space on an average-sized 500GB hard drive. Those savings add up. Second, DNGs have a longer shelf life. Imagine archiving a bunch of proprietary RAW files—but then that camera manufacturer (the originator of that proprietary format) goes out of business or simply gives up competing in the red-hot market. Decades later, those RAW files might be orphaned. On the other hand, Adobe has been doing business in the imaging-software market since 1982; it is totally dominant without a slight threat from competitors at this moment. We can be quite sure that the DNG format will be supported for a long time.

FILE SIZE

It is crucial to have an idea of the file sizes you are dealing with. To start with, you need to know how many memory

cards to bring to a shoot! File sizes determine how big a hard drive will be required and how many DVDs you'll need to archive your images. Here is a file-size comparison chart of a few popular models.

Besides the file size, the chart also provides the ratio between the file size and the number of megapixels. These numbers give us some clue about how "effective" the file is.

Now that the background is set, we can move on to build the foundation for you to become a Camera Raw master.

FILE SIZE COMPARISON (AVERAGE SIZE IN MEGABYTES)

CAMERA BRAND/ MODEL	MILLIONS OF PIXELS (MEGAPIXELS)	RAW		RAW COMPRESSED		NON-COMPRESSED RAW CONVERTED TO DNG	
		MB	MB/MP	MB	MB/MP	MB	MB/MP
Nikon D2X	12.2	19.9	1.63	9.99	0.818	10.8	0.89
Nikon D700	12	18.6	1.55	14.0	1.16	10.5	0.88
Canon EOS 5D Mk II	21	22.7	1.08	N/A	N/A	19.9	0.95
Canon EOS 30D	8.2	7.5	0.91	N/A	N/A	6.8	0.83

3. Basic Skills

In order to become proficient with Camera Raw, there are a few basic skills required—after all, you can't become a Jedi Master without understanding the Force. In this chapter, I am going to force some Force into you. The demonstrations and exercises in this chapter start with procedures in Photoshop; once the basics are covered, we will move on to bona fide Camera Raw techniques.

COLOR IMAGES IN RGB

When we press the shutter release, we take it for granted that the camera is recording our colorful world. You might be a bit surprised, however, to learn that the sensors in the camera only sense different levels of gray. In other words, sensors only produce black & white images. How in the world do we get our color images, then?

This is how: The "photosites," the individual sensors responsible for generating each individual pixel, see the light through tinted glasses, as illustrated in **image 3-1**. These tinted glasses are colored red, green, and blue—the three primary colors that make up the RGB color space. Mixing these primary colors in a specific recipe creates all of the other colors.

Essentially, the photosites detect the strength of red, green, and blue light and record them as three black & white images (called "channels"). How do these three images look? **Image 3-2** was made on the beach in Cancun. Notice how different each channel looks. Look at the red shirt under the umbrella. In the red channel, this shirt is nearly white. White (in an R, G, or B channel) means "more," so there is more red than green or blue on the shirt—which makes perfect

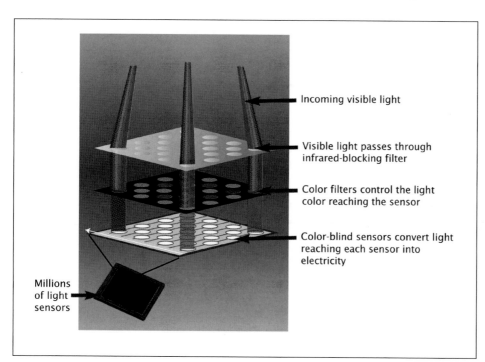

Incoming visible light

Visible light passes through infrared-blocking filter

Color filters control the light color reaching the sensor

Color-blind sensors convert light reaching each sensor into electricity

Millions of light sensors

Image 3-1. How an image sensor works.

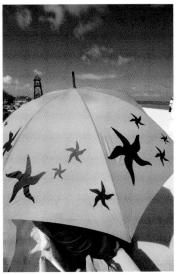

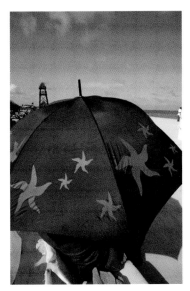

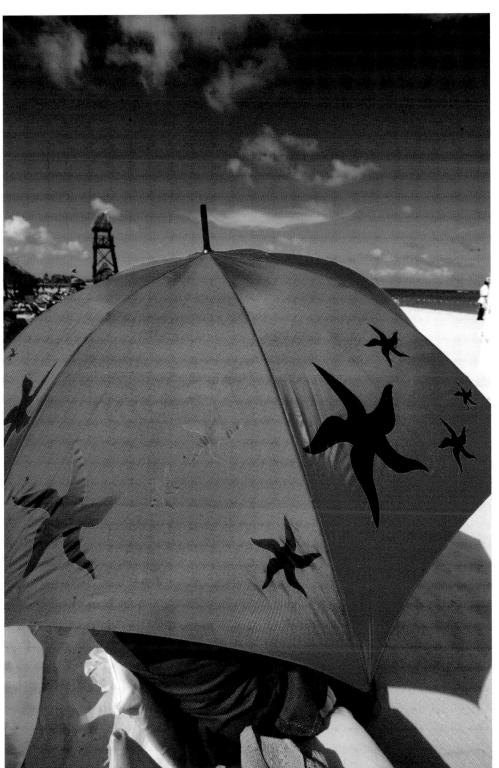

Image 3-2 (above). *The color image.*
Images 3-3, 3-4, and 3-5 (left column). *From top to bottom, we see the red (R), green (G), and blue (B) channels for the color image above.*

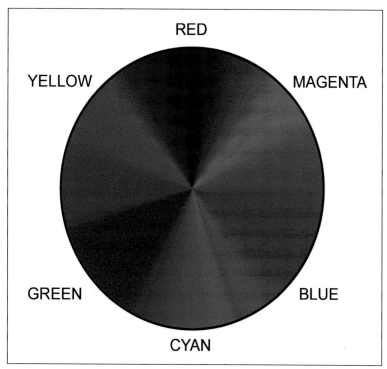

RED

YELLOW MAGENTA

GREEN BLUE

CYAN

Image 3-6. A color wheel.

Image 3-7. The Channels palette.

sense. How about the yellow umbrella? There is no yellow among our primary colors here. Comparing the umbrella in the three channel images, you will find more red and green, less blue. Clearly, yellow is made by mixing red and green.

At this point, it's time to look at a color wheel (**image 3-6**), a very helpful tool for gaining some insight on how the three primary colors interact with each other. While three of the six colors shown around the color wheel are not primary colors (at least not in the RGB color space), they were created by mixing their neighboring primary colors. Red and blue mix to create magenta; blue and green mix to create cyan; and green and red mix to create yellow. Returning to our example with the yellow umbrella, the color wheel confirms our recipe for yellow.

The colors that lie opposite each other across the color wheel are called complementary colors. Complementary colors cancel each other out. For example, where there is a lot of yellow, blue will be reduced. This is the reason why the yellow umbrella appears very dark in the blue channel.

Armed with this knowledge, you will be able to see more clearly how images are adjusted in Camera Raw. How about a little exercise?

EXERCISE: THE YELLOW UMBRELLA

1. Download the practice files from www.amherstmedia.com/downloads.htm. Open "umbrella.jpg" in Photoshop.
2. Go to the Channels palette. (If the Channels palette is not visible, go to Window>Channels to activate it.) The Channels palette should look like **image 3-7**.
3. Click on the red, green, or blue channel and observe the image.
4. Do not close the file yet; we will need it again in another exercise.

HISTOGRAMS

Arguably the single most important tool for digital artists, a histogram is a unique profile of an individual image's contrast. Histograms are very important to a Camera Raw master; they are the gauge for all the important adjustments to a RAW file.

If you think you have already mastered histograms, here is a deal for you: go to the end of this chapter and take the quiz on histograms. If you get all the answers right, skip this section and move on. If not, be good and keep reading.

Anatomy of a Histogram. Image 3-8 shows a histogram. Essentially, it is a chart on a two-dimensional space. The X axis (horizontal) is for brightness. The extreme left is black and the extreme right is white. Between these two points are different levels of gray. We also refer to each one-third of the brightness scale—from dark to bright—as the shadow, midtone, and highlight.

The Y axis (vertical) is for the total number of pixels; higher points indicate lots of pixels, while lower levels indicate fewer pixels. Keep in mind that instead of assigning a precise scale to the Y axis, most software makes the scale relative, making the histogram "look good"—neither too flat nor over the limit.

The gray blob here is the heart of the histogram. It is a chart representing how the pixels are distributed on the brightness scale. Look at the "peaks" of the histogram in **image 3-8**. There is a high peak right around the midtone, this informs us that the image has a lot of pixels that fall into the midtone range. The other lower peak indicates a large group of pixels (but smaller than the midtone group) that lie somewhere between the shadow and the midtone.

Now look at the "valleys" of the same histogram. The lowest valley we can see here is the totally flat area near the white point. This indicates a lack of pure white pixels in this image. The generally low "hills" on the right half of the histogram also suggest a overall dark tone in the image.

Before this discussion gets unbearably nerdy let's look at **image 3-9,** the photograph responsible for this histogram. This is a black & white image of a young woman using her cell phone in front

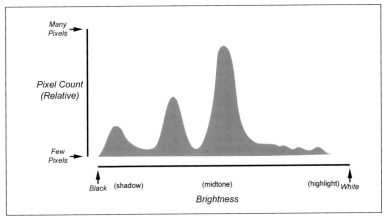

Image 3-8. Anatomy of a histogram.

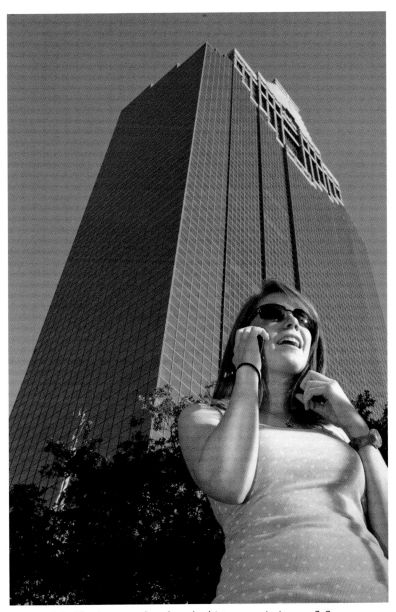

Image 3-9. The image related to the histogram in image 3-8.

of a skyscraper. It was taken in downtown Houston. Now compare the histogram to the image and try to locate which group of pixels are responsible for which area on the histogram. Look at the sky; it is obviously very uniform in brightness. This suggests a sharp peak in the histogram. It is around the midtone, which gives us the whereabouts of the peak—and it occupies a large area, which will produce a high peak. Without a doubt, the sky is responsible for the largest peak sitting on the midtone range.

EXERCISE: HISTOGRAM OF A BLACK & WHITE IMAGE

1. Download the practice files from www.amherstmedia.com/downloads.htm. Open the file called "cell.psd" in Photoshop.
2. First, check out the Layers palette. (If the Layers palette is not visible, go to Window>Layers to activate it.) There are two layers here. The layer named "B&W" is a channel mixer that is responsible for turning the image black & white. We will keep exploring in the black & white image before we examine the color one later.

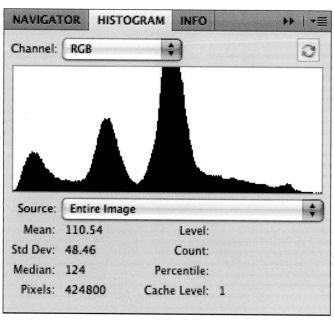

Image 3-10. The Histogram palette.

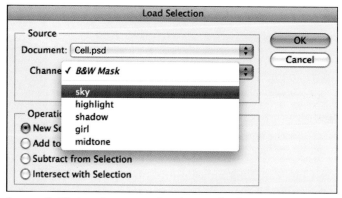

Image 3-11. Loading a previously saved selection.

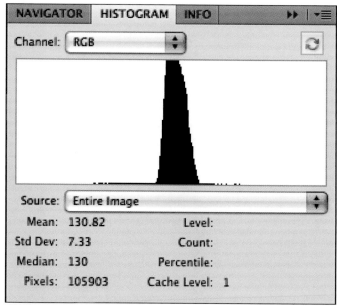

Image 3-12. The histogram of the sky.

3. Go to the Histogram palette. (If it is not visible, go to Window>Histogram to activate it.) **Image 3-10** shows what you will see. This is the histogram that we spent a page analyzing earlier.

4. I have made several selections that define significant areas of the image. Once a selection is loaded, the Histogram palette will display the histogram for the area of the image within the selection. Let's try this out. Go to Select>Load Selection. Once the Load Selection dialog box appears, keep every default value as is, and click on the Channel pull-down menu. You will see several saved selections—as in **image 3-11**. Choose "sky" and click OK.

5. Look at the image. The sky is selected. Now look at the Histogram palette. It should look like **image 3-12** now. Isn't this exactly the "center peak" we mentioned earlier?

6. Repeat the same procedure to load the "highlight," "shadow," "girl," and "midtone" selections. Observe which part of histogram they retain. You will notice that the height of the histogram is not maintained. As I explained earlier, this is due to the fact that the scale on the Y axis is relative—just to make the histogram "look good."

7. Keep the file open. We will use it again in the very next exercise.

HISTOGRAMS AND COLOR

You might wonder why we are looking at a black & white image when we live in a colorful world. The reason is that histograms get a little more complicated when the image is colorful. Why don't we get to the bottom of this, then, and move on to the color version (**image 3-13**)?

As we examine the color version of this photo, our interest will turn to a histogram that shows colors, as seen in **image 3-14**. What we are seeing here is three histograms in one. These three histograms are for red, green,

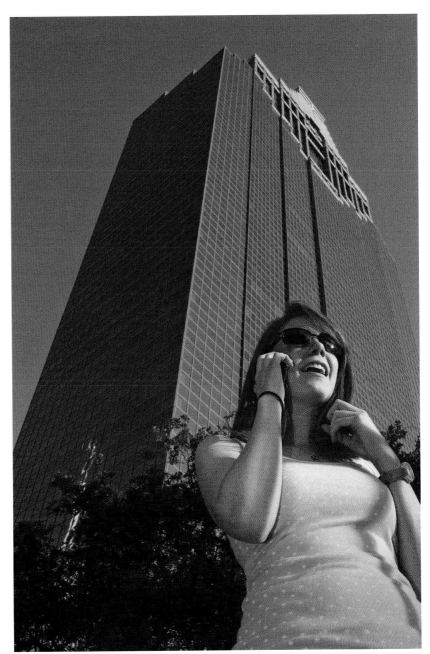

Image 3-13. The color version of the image.

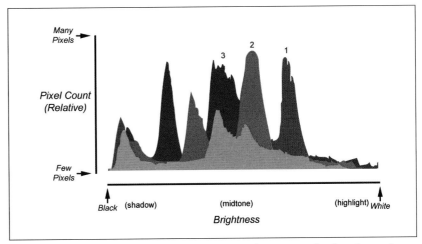

Image 3-14. The histogram of image 3-13 with separated color channels.

and blue—each marked with the corresponding color. It is very important for a Camera Raw master to be fully attuned to the three-color histogram; it is what you will use in the Camera Raw dialog box. For the time being, however, we will explore it in Photoshop.

EXERCISE: HISTOGRAM OF A COLOR IMAGE

1. If you did not open the file yet, download it from www. amherstmedia.com/downloads.htm. Then open the file called "cell.psd" in Photoshop.
2. Direct your attention to the Layers palette. (If it is not visible, go to Window>Layers to activate it.) Look at the layers. The one named "B&W" is the Channel Mixer responsible for converting the image black & white.
3. Click on the eyeball icon to the left of this layer to turn off the effect of the "B&W" layer. Now, the image turns colorful.
4. Go to Select>Load Selection. Click on the Channel pull-down and select "sky," as illustrated in **image 3-11**. In the Histogram palette, make sure the Channel pull-down on the top has "colors" selected.
5. Examine the histogram (**image 3-15**). This is the histogram for the sky.

Image 3-15. The histogram of the sky, now with color channels.

6. Repeat the same procedure and check out what the histograms are like for other areas of the image.

Isn't it fascinating that the pure blue sky is actually made of all three primaries? The point is how these three peaks are positioned. The blue is to the right, the green is in the middle, and the red is to the left. This means the blue channel is the strongest in this area, which determines the color.

EXERCISE: MANIPULATING CHANNELS WITH THE HISTOGRAM

1. Continue using the file we opened for the previous exercise. We will now see how changing the individual channels will affect the overall color in the image.

2. We will use the Levels to change the histogram of each channel. First, check the Layers palette and make sure the background layer is selected. Then, go to the Channels palette. (If the Channels palette is not visible, go to Window>Channels to activate it.) In the Channels palette, click on the red channel. Look at the image. This is a black & white image that happens to be the red channel. Look at the Histogram palette. (If the Histogram palette is not visible, go to Window>Histogram to activate it.) In there, you will see the histogram of the red channel.
3. Go to Image>Adjustments>Levels (or use the shortcut Ctrl/Cmd+L to bring up the Levels dialog box). In the center of this box, you will see a histogram identical to the one displayed in the Histogram palette. Click and drag the gray triangle beneath the histogram to the left until the number right under it reads 1.4. Do not click OK yet.
4. Look at the Histogram palette (not the histogram in the Levels, which unfortunately does not update interactively). First click on the Channel pull-down and choose Luminosity. Now we are observing the histogram for the red channel as a black & white image. It should look like **image 3-16**.

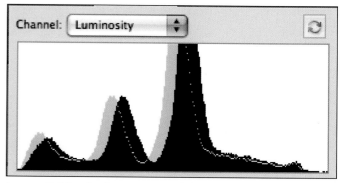

Image 3-16. The histogram showing the original (gray) and the adjusted (black).

5. The gray area denotes the original histogram. The black area, shifted to the right, is the histogram adjusted by the Levels. Back in the Levels dialog box, click and drag the gray triangle around to see the effect on the histogram. Still do not click on OK.
6. In the Histogram palette, click on the Channel pull-down and choose Colors. Now, try dragging that gray triangle around in the Levels dialog box. What you will see in the Histogram palette is totally fascinating (if you don't feel the fascination, you should seriously consider

picking up another hobby or profession). The red part of the histogram moves, but the other two colors remain in place!

7. Now click on OK in Levels. Return to the Channels palette, click on the RGB channel, and look at the image. The colors are quite affected. In order not to totally mess up the color before you probe any further, go to the History palette and undo the Levels (or hit Ctrl/Cmd+Z to undo the last step).

8. Now try the same procedures on the other channels. Try them on the yellow umbrella image, too.

Histograms in Camera Raw. Now that you have delved into histograms, let's have a look at how they are used in Camera Raw. Drum roll, please . . . let's have our first look at the Camera Raw dialog box, shown in **image 3-17**.

I am sure the first thing that caught your attention was the preview of the image. While the preview is the star in the RAW dialog box, the histogram at the top right corner also plays a critical role. Look at the whole array of adjustment sliders under the histogram. All of the effects from these adjustments are gauged with the preview *and* the histogram.

Pay special attention to the italicized "and" in the previous sentence. The preview and histogram have to go hand-in-hand to be meaningful. A very scientific-minded university student, excited by my explanation of the power of histogram, once exclaimed, "Great! We can just write a computer program to analyze the histograms and evaluate the images!" While I did applaud his thinking outside the box, the idea was inherently flawed. The use of histograms requires human judgement; images can only be evaluated by comparing them to their histograms. You will see this principle at work throughout this book.

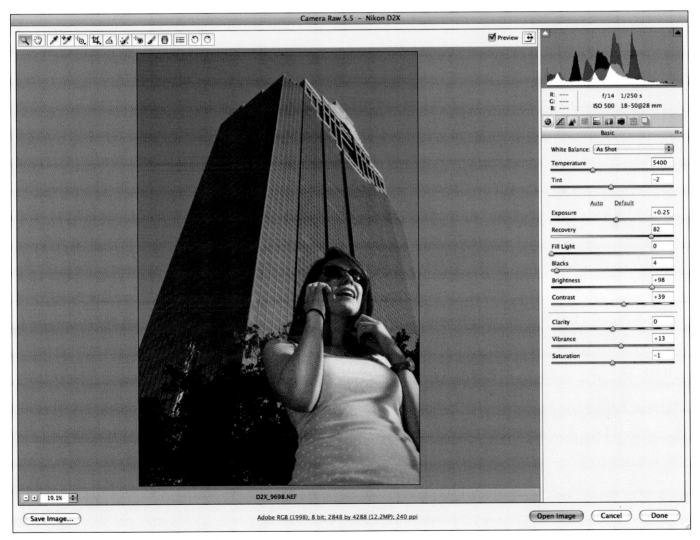

Image 3-17. The Camera Raw dialog box.

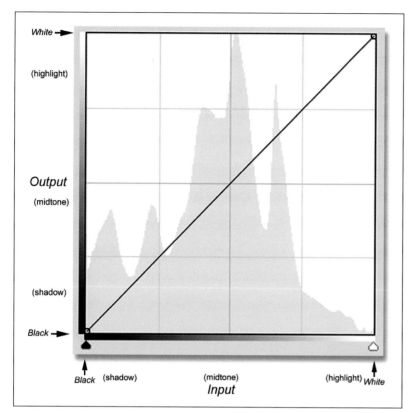

Image 3-18. Anatomy of a curve.

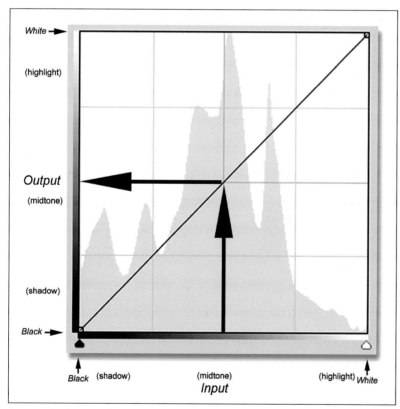

Image 3-19. How the input gray level is mapped to the output gray level.

TONE CURVES AND COLOR

An important tool in Camera Raw is tone curves. These make adjusting an image using complex mathematical formulas more graphic and less nerdy—or, in a word, easier. While histograms provide an intuitive profile of an image, tone curves provide a more sophisticated means of adjustment.

Like histograms, curves are also an important component in Photoshop. So let's learn how to use them by examining them inside Photoshop. **Image 3-18** shows the basic anatomy of a curve.

Look at the bottom (the X axis) of the chart. This is called the input of the curve. As in a histogram, the left is dark and the right is bright. The Y axis represents a spectrum of the same nature, with the bottom being dark and the top being bright. A tone curve is a mapping between the input (the X axis) and the output (the Y axis); in this illustration, the curve is actually a straight line that goes from the bottom left corner to the top right corner.

Here is how the mapping goes. Look at the red arrows in **image 3-19**. If you draw a line straight up from the midtone point of the input until it touches the curve, then turn 90 degrees to the left, you'll see that the output is exactly the same as the input: a perfect midtone. This is because the current curve is a straight line at a 45-degree angle. By changing the shape of the curve (so that it's no longer a straight line), we can adjust the color and contrast of our image.

If we change the curve so it has an upward bend, as seen in **image 3-20**, the input midtone will now map to something lighter than midtone on the output axis, as illustrated here by the red arrows. This results in a brighter image. Since the two end points of the curve have not been repositioned, however, the highlights and shadow are less changed (there is a smaller change between the input and output). When it gets to the black and white points, there is no change whatsoever. Look at how the image changed.

Now it's time for you to try it out. First, though, here are the methods to make curves twist and turn.

1. Click on the curve to place an anchor point on it.

2. Click and drag the anchor point to reshape the curve. A smooth curvature is maintained while you do this.

3. Repeat steps 1 and 2 to place multiple anchor points and make the curve twist and turn several times.

4. Click and drag the two end points to reposition them.

5. Press Ctrl/Cmd and click on an existing anchor point to remove it.

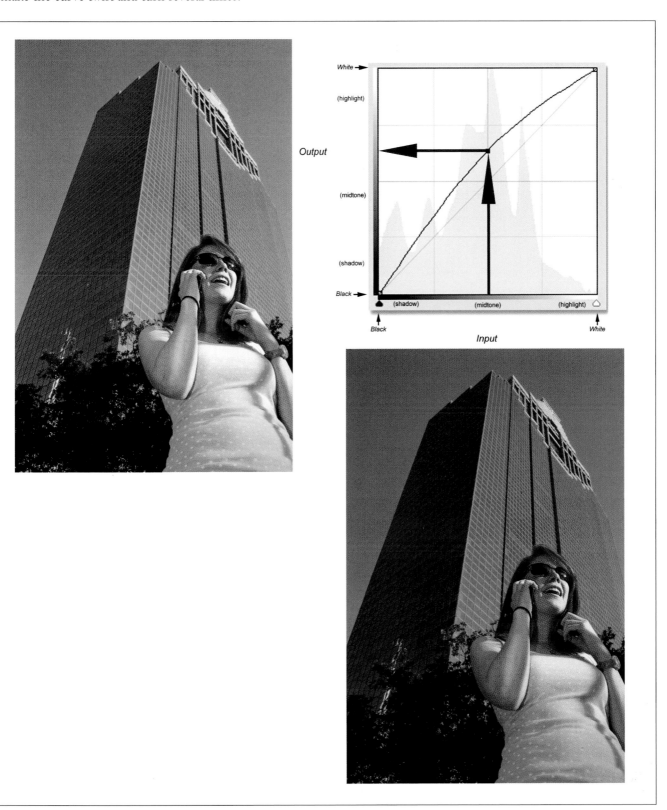

Image 3-20. A curve with an upward bend.

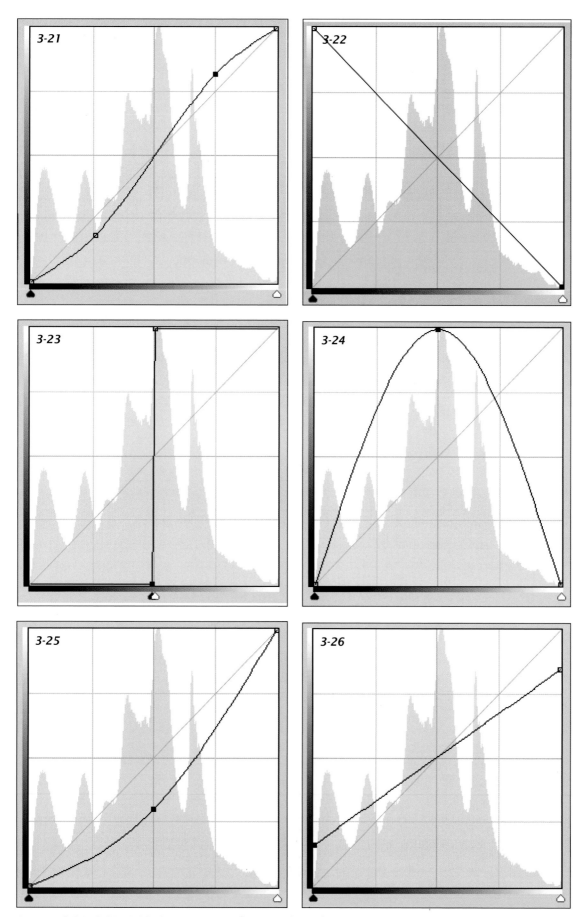

Images 3-21, 3-22, 3-23, 3-24, 3-25, and 3-26. *Adjust the curve to these shapes and see what happens to the image.*

EXERCISE: MANIPULATING AN IMAGE WITH CURVES

1. We will continue to the image called "cell.psd" from the on-line downloads.

2. If you haven't done so already, go the Layers palette and click on the eyeball icon to the left of the black & white layer to turn off the black & white effect. You will see the image regain its color.

3. At the bottom of the Layers palette, click on the Create a New Fill or Adjustment Layer icon. Then, choose Curves. You will see the Curves dialog box pop up in the Adjustments palette.

4. Now, adjust the curve into the shapes seen in (**images 3-21** through **3-26**). Observe how your image changes.

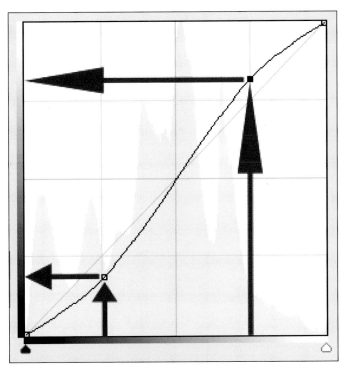

Image 3-27. A tone curve that increases contrast.

While some of the curves here are quite useful, others create rather funky looks. Unless you are specifically looking for those effects, these are just for the sake of learning. (And playing. Haven't you heard that all work and no play makes Jack a dull boy? Well, no play makes you a boring Camera Raw user, too.) The tone curve seen in **image 3-21** is typical for increasing contrast. Look at the red arrows added in **image 3-27** and you can see why: using this adjustment, the bright gets brighter and the dark gets darker—which translates to higher contrast.

Here is a challenge for you. Explain what the adjustments you made to the curves did to each image. I call this verbalizing, and it's a very useful learning approach. (It is especially handy if you have to turn around and teach your own students!)

Let's call it quits on laying this foundation, for the time being. There are additional aspects of colors, histograms, and curves that are useful for a Camera Raw user, but we will learn about them when they knock on the door. After all, a Jedi knight has to go out and fight the Sith Lords to become a master. So let's do it! (*Note:* If you have been to one of my workshops or read my other books, you'll already know about my Star Wars obsession. I find many similarities between learning Photoshop and mastering the martial arts, part of the Jedis' quest in Star Wars. Both require creativity, discipline, and patience. So the Star Wars references are, in fact, not just jokes—in case you doubt my seriousness.)

HISTOGRAM AND TONE-CURVE SHOW-AND-TELL

Histograms. Think you have mastered histograms and curves? **Image 3-28** features a set of images and histograms. Test your understanding of histograms by correctly connecting the images to their corresponding histograms. The answers (and some further questions for your consideration) appear in appendix D.

Curves. Now try one with curves. Look at **image 3-29**, which consists of a set of images and curves. At the top, you can see the original image—an eerie sunset shot taken the night before Hurricane Ike struck Houston in September, 2008. On the left, we have six images that have been altered by one of the curves on the right. Your task is to determine which curve is responsible for which image. When you are done, check your answer in appendix D.

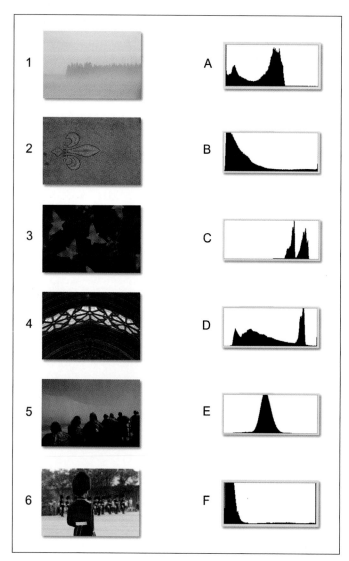

Image 3-28. Match the histograms to their corresponding images.

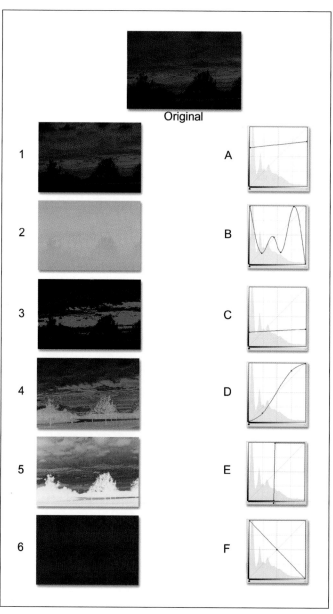

Image 3-29. Which curve is responsible for which outcome?

4. Into the Cockpit of Camera Raw

THE CAMERA RAW INTERFACE

The dialog box, or interface, for Camera Raw is rather complicated. It is packed with displays, sliders, and buttons. Some of these are much more visited than the others; however, the less-visited ones are not any less important.

Image 4-1. Our model in front of the sugar factory.

EXERCISE: THE CAMERA RAW INTERFACE

1. In Photoshop, open up the file called "sugarfactory.dng" from the companion files at www.amherstmedia.com/downloads.htm. This is a portrait taken in front of the abandoned sugar factory in our beautiful Sugar Land, Texas (**image 4-1**). The RAW image, originally shot with a Nikon D2X, has been converted to a digital negative with the extension .dng. (If you are not familiar with digital negatives, review the section in chapter 1 called "Things You Should Know about RAW.") Opening this .dng file will open the Camera Raw dialog box (**image 4-2**). Do not click Open Image.

2. Follow along with the explanation on the Camera Raw interface coming up in this section to familiarize yourself with its features.

Look at **image 4-2**. This is the Camera Raw interface. Look at the Preview panel on the left side. The image in the Preview panel is, by default, updated instantly according to

Image 4-2. The Camera Raw interface.

the adjustments you make. But do not overlook the little check box at the top right corner of the Preview panel. If it is checked, the image updates actively; if the box is unchecked, it does not. You might wonder why on earth you would not want to see the updated image. Here is a good use for that: you can check and uncheck that box, back to back, to compare the original image to the adjusted look.

To the right side of the Camera Raw interface you see a histogram at the top and lots of adjustment sliders below it. The default set of sliders are grouped under the Basic tab, but this is just one of the many groups organized into tabs below the histogram. Hover your curser over these tabs to learn their names from the "tool tips" pop-ups.

At the top of the Preview panel there is an array of buttons. These are the many tools you may want to use on the Preview panel image. By default, the Zoom tool is on; this is perfectly logical, since the Zoom tool is used ten times more frequently than all the other tools combined. The Zoom tool should make you feel at home because it behaves quite like the Zoom tool in Photoshop. Here are its basic functions:

1. By default, click on any spot in the Preview panel image to zoom in.
2. Press and hold Alt/Opt and click to zoom out (note that a minus sign appears, denoting zooming out).
3. Click and drag over a rectangular area to zoom in on that area.
4. At the bottom left corner of the Preview panel, plus/minus buttons and a pull-down of the image-view percentage serve as alternatives to using the Zoom tool.
5. Press and hold the Space bar to swap, on the fly, to the Pan tool (the hand icon) so you may reposition the image on the screen by clicking and dragging. Notice there are no scroll bars around after you zoom in, so remembering this shortcut is a must.

BASIC ADJUSTMENTS

We are approaching the hard core of Camera Raw. The adjustments under the Basic tab are the most powerful tools you will ever use in tweaking an image. These adjustments are all about the exposure of the image.

THE EXPOSURE SLIDER

The Exposure slider fixes over- and underexposure. However, there are intricate behaviors that you should know to make

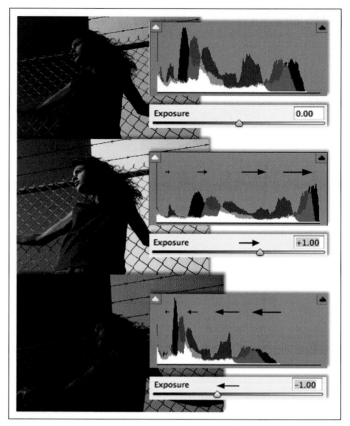

Image 4-3. How the Exposure slider affects the Preview and Histogram panels.

your image adjustment more successful. We will get to those in a few moments.

Image 4-3 illustrates the effect of the Exposure slider. Here, we are comparing the Histogram panel against the Preview panel when the Exposure slider is unchanged (top), is increased by one stop (center), and is decreased by one stop (bottom). (Remember your photography basics, here: One stop more means double the amount of light; one stop less means the light is cut in half.)

These adjustments result in a change in the brightness, but we should not rely on the Preview alone—after all, monitors can be deceiving. Even when your monitor is well-calibrated and you "know" the monitor on first-name basis, histograms are more dependable indicators of image brightness.

In this case, look at the original histogram. The lack of pixels near the white point suggests moderate underexposure. If we drag the slider to the right (or simply type "1" into the numerical input for Exposure, then hit Enter) we can increase the exposure by one stop. The resulting histogram will cover the whole spectrum of of brightness. The Preview panel suggests a brighter image with distinctly brighter highlights.

The important lesson here is a bit hard to illustrate on the printed page, but if you drag the slider back and forth, you might notice the phenomenon: the Exposure slider affects the right side of the histogram more than the left side. Essentially, when you move your slider around, the right side of the histogram changes more quickly. This is indicated by the red arrows in **image 4-3**.

The −1 stop indicates the perfect opposite of the +1 situation. The image appears more underexposed and the "gap" on the right side of histogram is even wider. The red arrows here once again indicate the Exposure slider's heavier influence on the highlight.

Clipping. We will learn another important lesson here while we are at the Exposure slider—a lesson about clipping. Clipping happens when part of the histogram extends past the limit of the brightness; after all, making something brighter than white or darker than black is impossible. For now, we will have a look at clipping on the right side of the histogram (*i.e.*, highlight clipping). We will deal with clipping on the left side of the histogram (*i.e.*, shadow clipping) when we move on to a different slider.

Let's start our look at highlight clipping by turning on the Highlight Clipping Warning as illustrated in **image 4-4**. (When you hover your curser over that little triangle at the top-right corner of the histogram, you will see a "tool tip" box pop up—just as seen in the illustration.) Click on the triangle icon to turn the Highlight Clipping Warning on. The "on" indicator is rather subtle; it is the white outline around the button of this triangle.

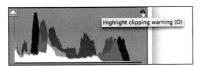

Image 4-4. The button to toggle the Highlight Clipping Warning on/off.

With the Highlight Clipping Warning turned on, go to the Exposure slider and drag it to the right to somewhere around +2.25 stop. Your Camera Raw dialog box should now look like **image 4-5**. Notice that several areas on the Preview panel image have turned red. These are the areas that are clipped.

So what happens when clipping occurs? I have a few terms to describe it. First, we might call it a "hot spot." This usually refers to highlight clipping on the face. Other terms are "burned out" and "blown out," both of which are general terms for highlight clipping. And here comes my favorite: "loss of details." When clipping happens, details are compressed to the very limit of the possible brightness. As

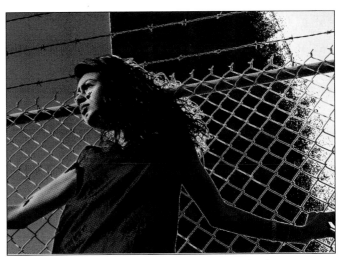

Image 4-5. The Highlight Clipping Warning displays as areas of red in the Preview panel.

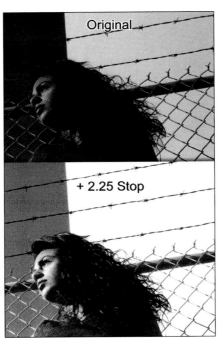

Image 4-6. Highlight clipping (with the warning turned off) is clearly visible when the exposure is increased excessively.

a result, subtle differences are eliminated—the details are gone. All three terms describe the phenomenon you can see in **image 4-6**. (If you want to see the same comparison illustrated here, simply turn off your Highlight Clipping Warning.)

Look at the building in the background. In the original image, its cylindrical shape was nicely presented with a gradual change of brightness. After adding 2.25 stops of exposure, the building looks like a flat, white wall. Now, look at the subject's face. Hot spots are visible—a no-no for portraiture. (Well, commercially speaking, it's a no-no; if we delve into the realm of fine art, nothing is no-no, is it?)

Generally speaking, we'd like to retain details and avoid clipping. But what if the image was shot with clipping?

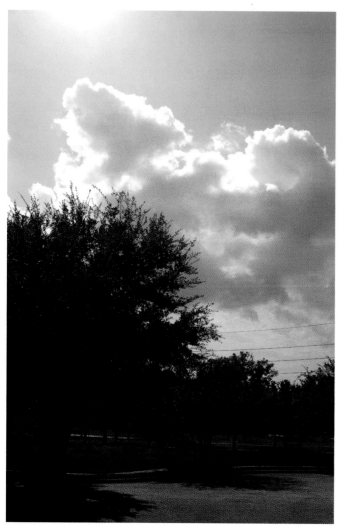

Image 4-7. A bright, sunny day in Houston.

Regaining Clipped Details. Look at **image 4-7**. This is a shot of my Houston neighborhood. Nice landscape isn't it? Unfortunately, this nice landscape was bathed in summery 100°F heat. I suppose we all have to accept the fact that there is no perfect place in the world but we sure can make the landscape look perfect in Camera Raw.

Of course, photographically speaking, the problem with this picturesque neighborhood is not the heat, it's the extreme difference in brightness between the bright sky and the shadowy tree. This forms a photographic dilemma. The difference is so great that it exceeds the maximum possible range of gray levels (known as the dynamic range). Although human eyes can see a whopping range of 24 stops, cameras (digital and film alike) can only see around 7 to 10 stops.

Maximizing the Dynamic Range. So what happens when we photograph such a scene? Clipping, blown-out areas, hot spots, loss of details—whatever you want to call

it. But, lo and behold, if you shoot this scenery in RAW, you can retain all of the details.

EXERCISE: MAXIMIZE THE DYNAMIC RANGE WITH CAMERA RAW

1. Find the file called "houstonlandscape.dng" among the companion files downloaded from www.amherstmedia. com/downloads.htm. Open it in Photoshop. You will be directed to the Camera Raw dialog box. Do not click Open Image.

2. Work along with the following discussion.

First, let's look at the Preview image and identify the problematic spots. Turn on the Highlight Clipping Warning by clicking on the triangle at the top-right corner of the histogram. Red spots appears on the "silver linings" of the cloud; they are clipped. Zoom in to that area. Now your Camera Raw dialog box should look like **image 4-8**.

Pay special attention to the circled area of the histogram. The "hill" of the histogram goes to the edge (the white point) and is cut off. This is the smoking gun of the crime called clipping.

Now, turn off the Highlight Clipping Warning by clicking on the little triangle at the top-right corner of the histogram. The red spots in the Preview image disappear. Get ready for the magical moment. Click and drag the Exposure slider to the left to around –1.5 stop and look at the Preview image (**image 4-9**). All the details are back! The boring clouds are now spectacular!

What happened? First look at the red circle in **image 4-9**. You will notice that the whole structure of the "lost hill" has been brought back from oblivion. Try dragging the Exposure slider back and forth between values of 0 and –1.5. You will see how the lost data is regained. This is a very important message: RAW keeps more than you ask for. So when you want some details back from the clipped range, you can have them back. **Image 4-10** shows a before and after comparison.

What would happen if the same shot had been made with the camera set to shoot JPGs, instead of RAW files? As luck would have it, I had set my Nikon D2X to shoot a RAW and a JPG simultaneously. So let's see if the same miracle can materialize with a JPG file. Since Photoshop CS3, it's been possible to open JPG images in Camera Raw. Now that sounds exciting—why don't we try it on our cloud shot?

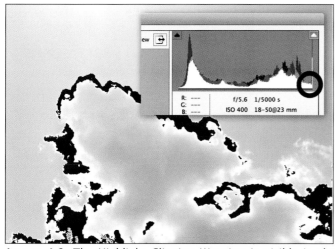

Image 4-8. The Highlight Clipping Warning is visible in the bright areas of the clouds.

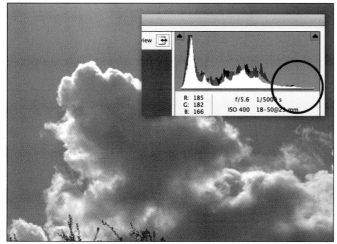

Image 4-9. The details in highlights are regained!

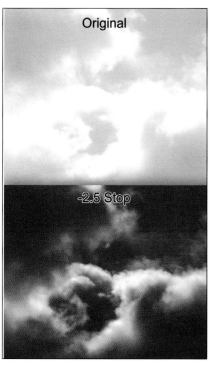

Image 4-10. A comparison of the cloud before and after the exposure adjustment.

EXERCISE: OPENING A JPG IN CAMERA RAW

1. Find the file "houstonlandscape2.jpg" among the companion files downloaded from www.amherst media. com/downloads.htm.

2. In Photoshop, go to File>Open as Smart Object. In the Open dialog box, choose file "houstonlandscape2. jpg", then go to the bottom left corner of the dialog box, click on the Format pull-down, and choose Camera Raw. Click on Open. (*Note:* You have to do the pull-down after you choose the file or it will revert to the default JPG setting.)

3. Our landscape image, now as a JPG, is opened in Camera Raw. Do not click Open Image. Work along with the following discussions.

At first glance, the Camera Raw dialog box looks exactly same as when we opened the DNG file. Now we will try to pull off the same miracle. Zoom in to the same area of the cloud. Reduce the Exposure slider to –1.5 and look at the Preview image (**image 4-11**).

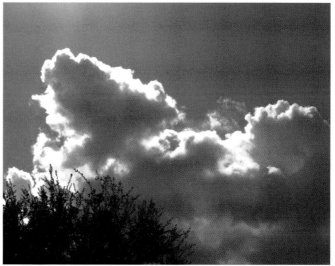

Image 4-11. Attempting to regain the details from the JPG image resulted in this.

Oh no! The details are not there! The difference is that JPG, unlike RAW, discards all the "excessive" data. Therefore, the clipped details were thrown away. This is the price you pay to get a tiny file.

Bracketing. We can further expand on the power of RAW to combat clipping by combining layers and layer masks in Photoshop. You may do this exercise the first time you read through this section or revisit it later, after more lessons about RAW have been learned.

EXERCISE: CAMERA RAW BRACKETING

1. Let's go back to "houstonlandscape.dng", downloaded from www.amherstmedia.com/downloads.htm.
2. Open it into Camera Raw and reduce the Exposure slider to –1.5. Nice clouds appear. But how about the trees? After this adjustment, the clouds are *al dente* . . . but the trees are way undercooked (**image 4-12**).
3. Click on Open Image to open the image into Photoshop.
4. Now, open "houstonlandscape.dng" again. Unlike a JPG or PSD file, Photoshop allows the same RAW file to be opened multiple times.
5. This time, drag the Exposure slider to the right to increase the exposure. Let's do +1. Look at the Preview image (**image 4-13**). The trees are reasonably bright now, but the sky is way blown out. Click Open Image to open this image into Photoshop.

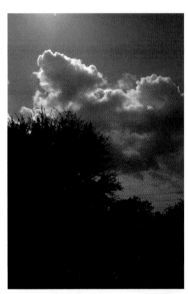

Image 4-12. Adjusting for the perfect clouds leaves the trees in the dark.

Image 4-13. Adjusting for bright trees blows the sky out.

6. You should now have two images open in Photoshop, one named "houstonlandscape.dng" and the other named "houstonlandscape-2.dng". Take a moment to verify the names at the tops of the images.
7. The next thing to do is to bring these two images into separate layers in one image file. Press V to activate the Move tool. If "houstonlandscape.dng" is not activated, click on it to make it so. Now click and drag that file into the "houstonlandscape-2.dng" window—but do not release the click yet! Press and hold Shift, then release your click. This will ensure that the layer that we dragged in will be perfectly aligned with the original background image.
8. In the Layers palette, double click the name "Layer 2" and rename it "cloud." Double click the name "background" and rename it "tree." Notice that when you do this to the background layer, the interface is different—a dialog box pops up. This is because you are not simply renaming the layer, you are also liberating the background to a much freer state. It will now be a normal layer.
9. Next, we will selectively show and hide the "cloud" layer. Based on our choices, in the final image we will see objects from both the "cloud" layer and the "tree" layer. To do this, we need to create a layer mask.
10. In the Layers palette, click on the "cloud" layer to activate it. At the bottom of the Layers palette, click on the Add Layer Mask button. A layer mask will be added to "cloud" layer, as illustrated in **image 4-14**.

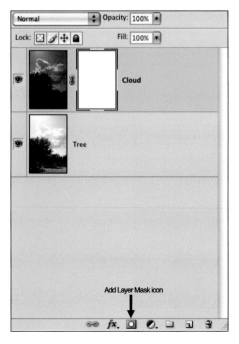

Image 4-14. Arrange the layers in the right order and attach a Layer Mask to the "cloud" layer.

11. The next step comes as a surprise to many of my students. Let's see how you react to it emotionally. Press B to activate the Brush tool. At the bottom

Image 4-15. The brush stroke to hide the trees on the "cloud" layer.

Image 4-16. Now the beautiful clouds and bright trees can coexist.

Image 4-17. The layer mask on the "cloud" layer.

of the Tools bar, make sure black is the foreground color. If not, press D to restore the default (or press X to swap the foreground/background colors). When black paint is ready for your brush, go to the Options (Window>Options makes this visible if it's not already) and make sure the Opacity is set to 100 percent. Use the [and] keys to adjust the brush size to around 1100, then use Shift+[to adjust the brush to 0 percent hardness. Both settings are indicated in the Brush drop-down of the Options. (Can't see your circular Brush cursor? Try unlocking Caps Lock.)

12. In the Layers palette, make sure the mask on the "cloud" layer is active.

13. Click and hold to start painting as indicated in **image 4-15**. Our target is the area under the tree line.

14. Cover the complete area under the tree line, including the ground. When you are done, the image should look like **image 4-16**.

Voilà! We are done! Look at the image. We have a beautiful sky and we have bright trees. What else can we ask for? Some of you might be wondering how can we get away without making a serious selection of the trees. Here is the answer: with the soft brush, we can hide the edges of our brush strokes amidst the natural variations of brightness in the image, producing a natural-looking image.

Do you want to see the layer mask itself? To do so, press Alt/Opt and click on the mask of the "cloud" layer in the Layers palette (**image 4-17**). The width of the transition zone, as indicated by the red arrows and made possible by the soft brush, is the essence of the technique here.

Why did I entitle this exercise "Camera Raw Bracketing"? Bracketing is a photographic technique that involves making multiple shots of the same scene or subject. The exposure of each shot is varied at a consistent setting (for example you might make three shots with exposure variations of –1 stop, 0, and +1 stop). In the film days, these images could be combined, using darkroom techniques, to bring out more details in all ranges of brightness. With the help of Camera Raw, we can make this happen with a single image—and we can reduce a multi-hour darkroom task to a five-minute Photoshop trick.

THE BRIGHTNESS SLIDER

Sometimes the Exposure slider alone can not solve our problem. Incorporating adjustments to the Brightness slider

will make our techniques more versatile. Let's examine a couple of images here.

EXERCISE: INCREASING BRIGHTNESS (WITHOUT CREATING CLIPPING)

1. Find the file called "tower.dng" among the companion files at www.amherst media.com/downloads.htm. This is, again, an Adobe Digital Negative file. (If you are not familiar with digital negatives, review the section in chapter 1 called "Things You Should Know about RAW.")
2. Follow along with the discussions.

When "tower.dng" is opened into Camera Raw, it should look like **image 4-18**. A look at the Preview image and the histogram suggests an underexposed image. This is rather common when we rely on the camera's TTL system to meter a bright sky.

To adjust this image, we will first increase the exposure. Let's turn on the Highlight Clipping Warning by clicking on the triangle at the top-right corner of the histogram. A white outline around that button indicates the "on" state.

Now, click and drag the Exposure slider to the right. While you do this, watch for red spots popping up on the Preview image. Stop when you hit +1.70 stop; the glare of the sun, the reflection on the windows to the left, and part of the cloud are covered in red. Clipping (loss of details) is happening in these areas. We do not want to lose the beautiful details of the cloud.

Drag the Exposure slider to the left and settle for +0.65 stop. All the red spots on the cloud are gone. Unfortunately, the image is still too dark. How can we increase the brightness

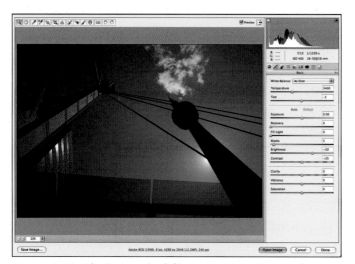

Image 4-18. The "tower.dng" file opened into Camera Raw.

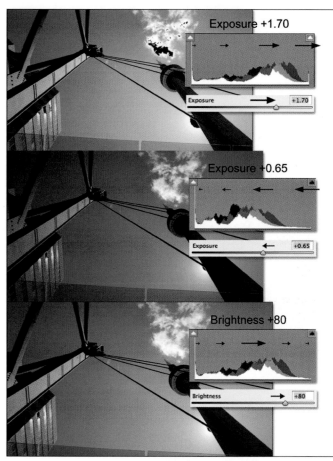

Image 4-19. The steps used to adjust the image.

without blowing out the cloud? The Brightness slider is the answer. Click and drag the Brightness slider to the right until the value hits +80. Now the Preview shows an image with well-balanced brightness and limited clipping.

How did this happen? Look at **image 4-19**. Pay special attention to the red arrows on the histogram. They indicate the movement of the histogram when we pull the sliders.

At the top of the illustration, you can see that the right side of the histogram went overboard quickly. This is because the Exposure slider affects the highlights more (as noted earlier in this chapter). Fortunately, pulling back to +0.65 quickly restored most of the clipped highlights.

The Brightness slider behaves differently. It affects the midtones more than the highlights and the shadows. In other words, the midsection of the image moves fastest when you drag the Brightness slider. As illustrated here, when the Brightness slider is dragged to +80, the midtone of the histogram moves to the right, but the highlight moves very little, avoiding the highlight clipping. Now the whole image is correctly exposed and the details in the highlights are preserved.

You should have tasted the RAW flavor by now. Using the sliders, we are manipulating images to achieve the looks we desire. While we do this, we use the histogram to gauge our results. We will handle many more examples in a similar manner.

EXERCISE: EXPOSURE AND BRIGHTNESS SLIDE AWAY FROM EACH OTHER

1. Find the file "yellowstone.dng" among the files downloaded from www.amherstmedia.com/downloads.htm. Open it in Photoshop and you will be in the Camera Raw dialog box, as seen in **image 4-20**. This is an image of a spring in the great Yellowstone National Park. Unfortunately, it was taken on a not-so-brilliant cloudy afternoon—just a day before I became trapped there in a snow storm. The lighting conditions contributed to the low-contrast (or flat) image.

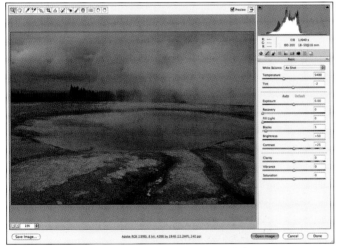

Image 4-20. The Yellowstone image opened into Camera Raw.

2. Looking at the histogram, you can see that the shot is also underexposed. Therefore, we can be sure that our adjustment can start with the Exposure slider bar going to the right. You will find the image is still totally free from highlight clipping even when you increase the exposure to +2. Let's settle for that—for now.
3. Look at the Preview image. Adding this amount of exposure makes the image rather bright. Although this resembles what I saw with my eyes under these cloudy conditions, it does not make a good print. We want more drama. This means we need more contrast and more color. It might surprise you that the logical next step will be to reduce the brightness.
4. Click and drag the Brightness slider to the left until it hits the −10 mark. The Preview image now looks a lot

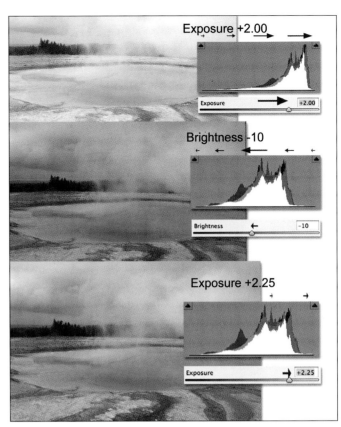

Image 4-21. The steps used to adjust the Yellowstone image.

more interesting. The color of the spring and the texture of the mineral stains are much more prominent. This is illustrated in **image 4-21**.

5. The reason these seemingly counterproductive steps work is because, as mentioned earlier, the Exposure and Brightness sliders work on different parts of the histogram. Look at the red arrows in **image 4-21**. When we moved the Exposure slider to the right, the highlights rushed to the white point. When we slid the brightness to the left, the midtones were brought back to the darker end. Since the highlights and midtones are more separated, the contrast increased.
6. Now, direct your attention back to the right edge of the histogram. You will find that the leftward movement of the Brightness slider did not exactly leave the highlight alone. It has made it move slightly to the left. To compensate, increase the Exposure slider to +2.25 to regain the strength of the highlight. As you can see from **image 4-21**, the scenery now looks much more vivid.

There is more you can do to improve this image. Read on to the next section—and do not close the Camera Raw dialog box yet!

THE CONTRAST SLIDER

It's time to meet the Contrast slider. As the name suggests, it affects the contrast of the image. Here's a more analytical view: when the Contrast slider is set to a higher value, it spreads the histogram to its extremities. Imagine the histogram being cookie dough. Increasing the contrast is like squeezing the dough in the middle; it expands outward. Let's see how the Contrast slider can help us further improve our Yellowstone shot.

EXERCISE: THE CONTRAST SLIDER'S EFFECT ON THE HISTOGRAM

1. Continue on with the file called "yellowstone.dng". This should still be open in your Camera Raw dialog box.
 If not, refer to the previous exercise ("Exposure and Brightness Slide Away From Each Other") to bring it to readiness.
2. Work along with the following discussions.

In the Camera Raw dialog box, drag the Contrast slider all the way to the right until it hits the +100 mark. Look at the histogram; it now covers the whole range of brightness pretty nicely. No clipping is occurring on either end. This is illustrated in **image 4-22**.

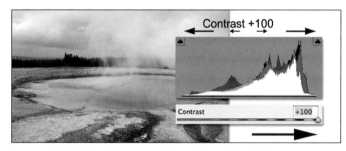

Image 4-22. The Contrast slider adjusted to 100+.

Give yourself a sense of achievement by checking and unchecking the Preview check box at the top right corner of the Preview image. When it is unchecked, the Preview image goes back to its unadjusted state. What a difference have we made!

Do you think that we are cheating by making the image look nicer than it actually was? I have news for you: maestro Ansel Adams, inventor of the Zone System, spent hours and hours in the darkroom to improve the look of his landscape prints. What we are doing here is continuing the tradition of Ansel Adams' photographic craftsmanship. Craftsmanship makes art possible.

OTHER EXPOSURE ADJUSTMENTS: RECOVERY, FILL LIGHT, AND BLACKS

You have learned about how the Exposure, Brightness, and Contrast sliders affect the histogram in different ways. Sometimes we want to make even finer adjustments to the histogram; we need more localized shifts to pinpoint the problematic zones.

Let's return to our image of the Houston landscape. Our task here will be to make all the needed exposure adjustments in Camera Raw—without using the layers and layer-mask technique introduced earlier in this chapter (in the exercise called "Camera Raw Bracketing"). Let's see how we can achieve a similar result.

EXERCISE: FINE-TUNING AN IMAGE

1. Find and re-open the file called "houstonlandscape.dng" from the downloaded companion files. This will open the Camera Raw dialog box, as seen in **image 4-23**.
2. Our first step is to bring back the details in the cloud. To do that, we need to bring the histogram structure

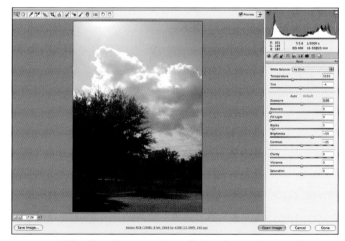

Image 4-23. The Camera Raw dialog box with the Houston landscape image visible.

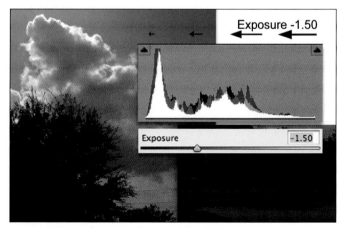

Image 4-24. Adjusting the Exposure slider to –1.50.

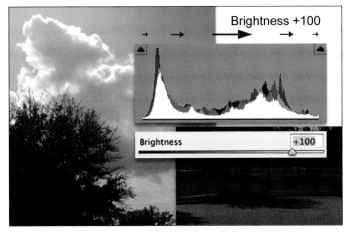

Image 4-25. Adjusting the Brightness slider to +100.

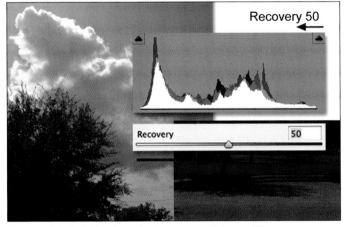

Image 4-26. Adjusting the Recovery slider to 50.

at the extreme right, originally clipped, back into the range. The Exposure slider is our best choice because it can compress the histogram toward the left—with an emphasis on the highlight. Drag the Exposure slider to –1.50. The sky looks great but the trees are way too dark (**image 4-24**).

4. Now we will use Brightness slider to push the middle part of the histogram back to the right to regain some brightness in the midtones. Click and drag the Brightness slider to the right, to a value of +100. This improves the overall brightness, but some contrast in the cloud is lost (**image 4-25**).

Recovery. Recovery is a slider in charge of bringing highlights back from oblivion when they fly too high. It affects only a very small part of the histogram at the extreme right end of the graph—where the highlights reside.

5. As you increase the amount of Recovery, the histogram near and beyond the white point is pushed to the

left. Drag the Recovery slider to 50 and you will see improvement in the details on the cloud (**image 4-26**).

Fill Light and Blacks. Now look at the image. It seems that the tree and ground are still a bit dark. We need an adjustment that targets on only the shadow area of the histogram—this is the job of the Fill Light and Blacks sliders, which affect the left side of the histogram. Comparing these two, the Fill Light slider covers a larger portion of the histogram. When it is moved to the right, the shadows brighten. The Blacks slider targets a smaller area; it affects only the extreme left edge of the histogram. When dragged to the right, the left edge of the histogram will be pushed toward—or even beyond—the black point. And yes, the Blacks slider can cause shadow clipping when you overuse it.

6. Brighten the shadow by dragging the Fill Light slider to the right—to the 35 mark. There is visible improvement, but the image now looks a bit "washed out." This is an indication that it lacks true black. Look at the very left of the histogram. The foot of the hill does not touch the black point. This confirms the "washed out" look (**image 4-27**).

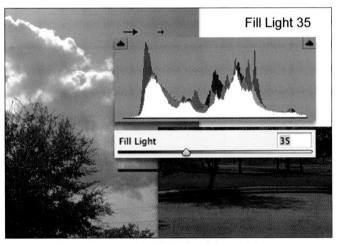

Image 4-27. Adjusting the Fill Light slider to 35.

7. To fix this, we need the Blacks slider. We will also use some help from the Shadow Clipping Warning, so go to the triangle button at the top left corner of the histogram and click to turn it on. The white outline indicates the "on" status.

8. Note that the default value of the Blacks slider is 5. We will increase that by dragging it to the right until the value reads 10. Now, look at the histogram (**image 4-28**). The left edge sits right on the black point and no

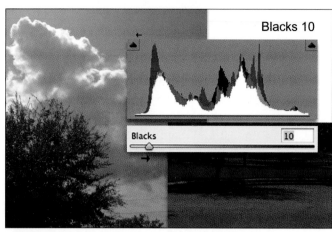

Image 4-28. Adjusting the Blacks slider to 10.

Image 4-29. The Shadow Clipping Warning is visible.

Shadow Clipping Warning appears in the Preview image. Just for the sake of experimenting, drag the Blacks slider to the right slowly. When it passes the 15 mark, you will start to see blue spots—indicating shadow clipping—popping up in the Preview, as illustrated in **image 4-29**. Pull the Blacks slider back to the left to 10.

COLOR ADJUSTMENT

Now that we have explored all the means to adjust brightness, it is time to deal with color. Many photographers refer to this as "color correction," but I dislike that term. "Correction" suggests there are correct colors and incorrect ones. There is no such way to label colors. No one would say the colors in Vincent Van Gogh's *Starry Night* are not the "correct" ones. The color of a photograph should not be judged as correct or incorrect either.

Color is a matter of taste. There are also considerations for different image applications. Fine-art photographers care

less about presenting color in an unbiased manner. Fashion photographers, on the other hand, need to be truthful about how the garments look. But how many of my dear readers are doing fashion photography—or another kind of photography where you have to be precise about color? If we sail on the sea of photography, we would run ashore on just a few tiny islands that need exact colors.

Do I mean we can get sloppy about color? Absolutely not. When it comes to color, my strategy is to have dependable equipment, the skills to manipulate my image files, and the vision to determine what looks the best. In other words, hardware, technique, and judgement are all required.

Calibration and Profiling. Before you do anything about color, you need to make sure your monitor is being honest with you. Unfortunately, finding an honest monitor is as difficult as finding an honest politician. Fortunately, while it's hard to make politicians honest, monitors can be calibrated. But monitors are not the only givers of unpleasant surprises. Output devices—from the inkjet printer on your desk to the lab services you pay for—can be a source of grief. How do we foresee the results before we waste time, money, or precious trees on useless prints?

This brings us to the idea of profiling. All devices have certain biases; a monitor can be too reddish at the midtone, or a printer can be heavy on the blue near the highlights, for example. By analyzing these biases (measuring how a device renders color) we can generate a profile for each device. This profile can then be applied to counteract the biases of the device.

When we talk about calibrating a monitor, we are not attempting to adjust any nuts or bolts. Instead, we are providing the computer with a set of instructions (called a "profile") to use when displaying images on a particular monitor. These instructions tell the computer how to "pre-distort" the signal it sends to the monitor—that way, when the monitor distorts it, the colors actually turn out right!

How about printing devices? A similar calibrating process can be used to generate a profile. This profile can then be used to "soft proof" an image in Photoshop. This allows you to preview on your monitor how the image will look when output on a given printer. The sad reality is that you can't make a printer do exactly what you want, but this process can be helpful for predicting the outcome.

Calibration and profiling are a prerequisite for any form of color adjustment. Products designed for the purpose of color-profiling all ship with step-by-step instructions for

using them, so I am not going to include those instructions in this book.

The Color Wheel Revisited. Before we start tweaking color in Camera Raw, let's have another look at the color wheel, which was introduced in the previous chapter. Now, let's look at it with more than a little twist.

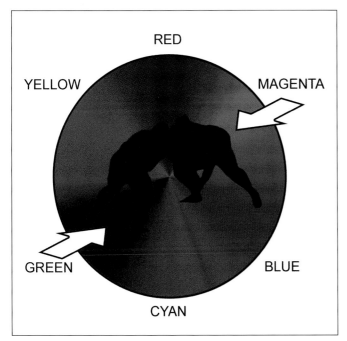

Image 4-30. Sumo wrestling on the ring that is the color wheel.

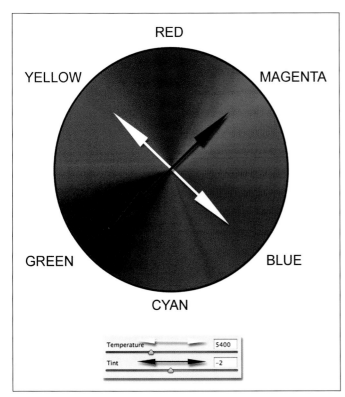

Image 4-31. Camera Raw color sliders and how they push the image around a color wheel.

Our whole business of color adjustment can be viewed as sumo wrestling on the color wheel. You, as a sumo, wrestle with the color shift you want to overcome. Now, visualize yourself wearing the mawashi on your 80-inch belly, ready for a bout against the bad colors. (That is, if this thought does not gross you out.)

A more serious look at how to perform this color wrestling is shown in **image 4-31**. At the bottom of this illustration you can see the two sliders we use for color correction in Camera Raw. Essentially, when these two sliders are dragged around, the image is shifting its position on the color wheel. The Temperature slider goes from yellow to blue. The Tint slider goes from green to magenta. With adjustments in these two directions, we can go virtually anywhere on the color wheel. Most adjustments can be handled with a moderate to large displacement of the Temperature slider and little or no displacement of the Tint slider.

Color Temperature. A comprehensive understanding of color temperature will not significantly improve your ability to use Camera Raw for color adjustment, but it can ease some of your anxiety about it. The following overview is sufficient to embark on the color adjustment tasks at hand.

Measured in Kelvin (K) degrees, color temperature is the measurement of the color of light in relation to its absolute temperature. In the ideal situation, a certain Kelvin value yields a certain color of light. This ideal situation covers most of the light sources around us. When the color temperature is low, the light is red. As the temperature rises, the color shifts to yellow, green, blue, and purple.

Our Temperature slider in Camera Raw covers only part of the whole spectrum of color temperature. It is, however, enough to cover all of the light sources around us. Look at the Temperature slider in **image 4-31** again. The slider thoughtfully provides a hint of color from the blue on the very left (valued at 2000K) to yellow on the right (valued at 50000K). You might say, "Wait a minute . . . this is opposite of the spectrum mentioned above." You are right.

Here's why the colors on the slider were laid out this way. When the setting of Temperature slider matches the color temperature of the light used to create the image, the image looks neutral. When the slider's setting is higher than the light's color temperature, the image looks yellowish. When the slider's setting is lower than the light's color temperature, the image looks bluish.

To try this out, open any RAW image and move the Temperature slider to the left. You will see a more bluish

preview. Do the opposite and you will see a more yellowish preview. This is the reason why the slider is colored that way. It is relative, reflecting how the colors look in relation to the settings.

If we could put the U.S. political spectrum on a slider, from the left wing to the right wing, it would probably look like **image 4-32**. If you pulled the slider (which indicates the midpoint) all the way to the right, all of our politicians would appear very liberal (most of them would fall to the left of the midpoint). If you did the opposite, they would look like hard-core conservatives (most of them would fall to the right of the midpoint). It is all relative, isn't it? So is our Temperature slider. I hope this political analogy helps—if not, I hope you at least had a good laugh. Now please come back with me to the world of Camera Raw. (By the way this political slider is not available in Camera Raw as of version 5.4. If it were, I'm sure all the voters would want to download a copy from Adobe. If it ever does become available, please don't misuse it; it is for you to adjust your own point of view, not to adjust the politicians!)

Image 4-32. A "Political" slider.

THE TINT SLIDER

As mentioned in the last section, the concept of color temperature is based on an ideal situation in which the light is strictly related to its temperature measured in Kelvin degrees. Candles, light bulbs, and sunlight are pretty much covered under this setup. However, there are plenty of light sources that are not ideal. Fluorescent light is a common one. Fluorescent sources do not emit light by increasing temperature; instead, light is produced when electrons jump among different energy levels. When this happens, a certain color can be exaggerated. In the case of fluorescent

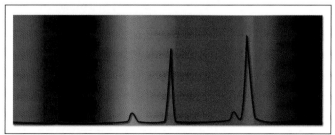

Image 4-33. A typical fluorescent lamp's color across the spectrum.

light, there is a lot of green. Look at **image 4-33**. This is by no means a scientific representation of fluorescent light's spectrum, but it gives us artists a very good idea.

Other realities can disturb our perfect world of light. The most common one is the interior color. If you shoot in a ballroom with red wall paper, for example, the light will be tinted with red.

In either of these cases, the Tint slider can be used to make the color look better. If the color does not look right after fiddling with the Temperature slider, the Tint slider should be the next thing you try.

WHITE BALANCE SETTINGS ON THE CAMERA

In the film era, films with daylight and tungsten color balances were offered to produce neutral looks under the corresponding types of light. One could also use color filters to adjust how colors were recorded. On digital cameras, the story is much simplified—or is it?

Many photographers leave the white balance set to automatic. The auto setting works in a couple ways. One way is to have the camera analyze the image and balance it out so the "average" of the colors in a shot will turn out to be gray. This is called the gray-world algorithm. So what if you put a model in front of a pure yellow wall? The model's face might record as bluish when the camera attempts to balance out the yellow with more blue. Some cameras use a "third eye," which is a sensor without a lens, to detect the color of the light around the camera. With this system, problems can arise when you stand under one light source and shoot into another light—say, shooting into a window from outside the building. Another problem with the automatic white balance is that it generates a different white balance for every shot. This makes it harder to identify an adjustment that can be applied to a group of shots.

I much prefer the manual settings. With manual settings like "sun," "incandescent," or "flash," a specific Kelvin temperature is assigned. Compare **image 4-34** to **image 4-35**. These two images of a beautiful bride were taken in the dressing room and at the altar. The white balances were set to "flash" and "incandescent" respectively. When processing **image 4-34** in Camera Raw, the Temperature slider was set to 5800K to match the approximate color temperature of the flash. When processing **image 4-35**, the Temperature slider was set to 2850K for the mostly incandescent lighting in the sanctuary.

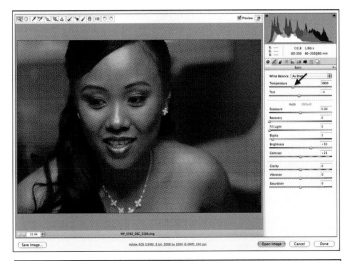

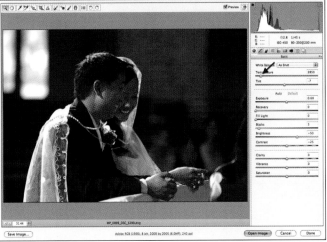

Images 4-34 and 4-35. How the camera's white balance setting affects the default color settings in Camera Raw.

With the camera's white balance putting the color temperature into the right vicinity, we can move on to fine-tune it.

THE MOOD OF THE SUN

Look at **images 4-36** and **4-37**. Both images were made with the white balance on my Nikon D2X set to 5400K. Comparing the previews, you see rather different color tones. First compare the skin tones. In **image 4-36,** the bride has a warm-looking skin tone—almost glowing like gold. In **image 4-37**, the skin looks cooler; there seems to be a touch of blue or even green. Now, compare the gown in the two images. In **image 4-36**, the gown is pure yellow with a high saturation. In **image 4-37**, the yellow has a visible shift toward green. The cause of these differences was the weather—in **image 4-36,** the sun was direct; in **image 4-37,** it was overcast. The color temperature increased quite a bit because the scattered blue light (as you see in the blue sky) has more of an effect when the sky is overcast.

Which image is correct? My personal taste favors **image 4-36**. So the task, now, is to align the skin tones in **image 4-37** to those in **4-36**.

EXERCISE: MATCHING THE SKIN TONE

1. From the downloaded companion files, open the files called "indianbride1.dng" and "indianbride2.dng" simultaneously. The Camera Raw dialog box will open with these two images available in the left column as thumbnails.
2. Work along through the following discussions.

The preview of "indianbride1.dng" seems to be a bit dark. Its histogram is heavy on the left, so that confirms our observation. We will fix this first before we move on to adjusting color. Should we start with the Exposure slider? The answer is no. In **image 4-38**, the circled area of the histogram indicates that our highlight is already pushing the white point. Any increase using the Exposure slider will

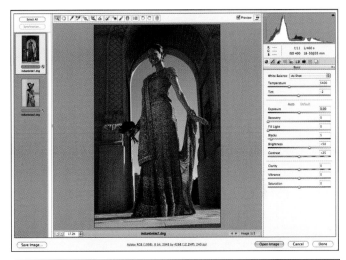

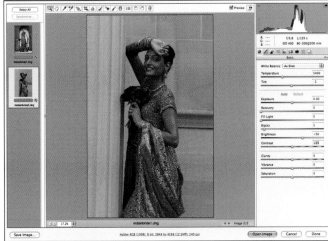

Images 4-36 and 4-37. Your mission: Make the skin tones consistent in these two shots.

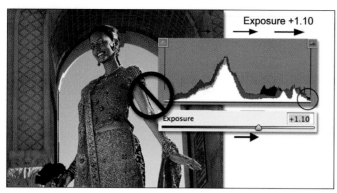

Image 4-38. Using the Exposure slider on this image blows out the highlights.

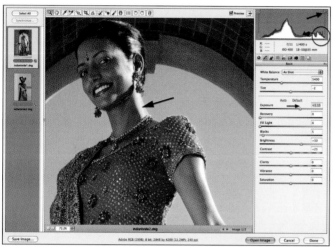

Image 4-39. Highlight clipping occurred at the bright spots.

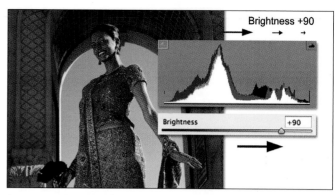

Image 4-40. Using the Brightness slider on this image preserves the highlight detail.

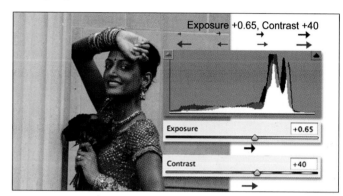

Image 4-41. Adjusting the Exposure slider to +.65 and the Contrast slider to +40.

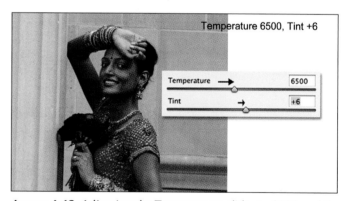

Image 4-42. Adjusting the Temperature slider to 6500 and the Tint slider to +6.

probably blow out the highlight and cause loss of details. Let's try it, though. Turn on the Highlight Clipping Warning by clicking on the triangle at the top right corner of the histogram. Then, drag the Exposure slider to the right. Immediately, red warnings will pop up like wildfire around her gown, face, and on the background, as indicated in **image 4-38**. If you want to closely observe these hot spots, turn off the Highlight Clipping Warning and zoom in on the Preview image.

I want to delve a little deeper into the clipping topic here by showing you **image 4-39.** Here, the Preview has been zoomed in to the bride's face and the Highlight Clipping Warning has been turned off. In this illustration, the Exposure slider was increased to +1.15 stop. Check out the histogram in the red circle area. Clipping is evident. Now look at the Highlight Clipping Warning icon—it has turned yellow. What does that mean? The yellow triangle at the Highlight clipping warning means that the red and the green channels have exceeded the highlight (together, they make yellow).

Now look at the Preview area indicated by the red arrow. This is a hot spot. This hot spot, according to the histogram, has lost some yellow in it because the red and green channels can't supply any more color. Try dragging the Exposure slider back and forth; you will see that the triangle changes color. When the value gets to +1.50, the triangle turns white, indicating that our hot spots have lost their color completely.

Back up your Exposure slider to 0. If you remember what you learned earlier about the difference between the Exposure and Brightness sliders, you'll know that the Brightness slider would be a better choice here because

it mainly affects the midtones, leaving the highlight areas alone. Drag the Brightness slider to +90 and see how the overall brightness improves (**image 4-40**).

Now that "indianbride1.dng" looks ideal, let's adjust "indianbride2.dng" to match it. If you have both images open in Camera Raw, click on the thumbnail of "indianbride2. dng" to bring it to the stage. Let's fix the brightness first. Dragging the Exposure slider to +.65 and the Contrast slider to +40 should suffice.

Next, we need to change the Temperature slider to compensate for the higher color temperature under the overcast sky. Drag the Exposure slider to the right to 6500K. Now the preview shows a much warmer look. However, if you click on the thumbnail of "indianbride1.dng" to compare, you can see that the skin tone in that image still has much more red. We do not have red in the sliders. So what will we do to increase the red? Look back at **image 4-31**. In order to gain red, we need to increase yellow and magenta. We have done yellow (using the Temperature slide), now let's do magenta using the Tint slider. You should try it by applying a small change, then make comparisons between the two images. I found +6 on the Tint slider did the trick (**image 4-42**).

Compare the two images again. Are you happy with the result? I am not.

VIBRANCE AND SATURATION

We normally think of color adjustment as adjusting the color balance, which is what we have been doing so far. Unfortunately, despite the fact that our second image is getting closer to the brilliant colors in the first image, it is still a bit flat. In a case like this, we need to do something about the color saturation.

In Camera Raw there are two sliders for saturation. One is Vibrance. The other is, of course, Saturation. But which one should we use? What's the difference between them? Why don't we try them to see the difference for ourselves?

Let's first drag the Saturation slider to +30, as illustrated in **image 4-43**. While the sari gains impressive yellow, the bride's skin tones have gone haywire—she look like she has jaundice. Look at the roses, too; they look fake.

Now, pull Saturation slider back to 0 and pull the Vibrance slider to +30. The yellow on the sari now looks very similar to what we have in "indianbride1.dng". The skin tone is also similar and remains pleasant. The granite on the building looks a bit warmer but is still quite neutral (**image 4-44**).

Let's talk about the difference between Vibrance and Saturation. Whereas Saturation indiscriminately adds color to all areas, Vibrance saturates color in areas where there was already a considerable amount of color. For areas with less colors, it saturates them very sparingly.

Look at **images 4-45** and **4-46**. These are the two bridal shots with our adjustments applied. Aren't they beautiful? The skin tone and color of the sari are satisfactorily consistent, too. Mission accomplished!

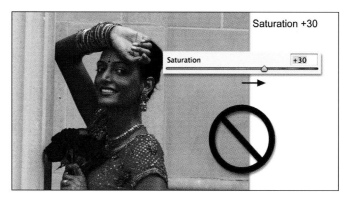

Image 4-43. Adjusting the Saturation slider to +30.

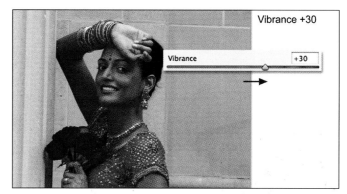

Image 4-44. Adjusting the Vibrance slider to +30.

Image 4-45 and 4-46. Now the skin tones are consistent.

THE NOT-SO-MAGNIFICENT FLUORESCENT

We are surrounded by fluorescent lights. The reasons why I love them and hate them sound literally the same: they are green! They are green in terms of being more energy efficient, but they are also green in terms of the light color they emit. As presented in **image 4-33**, the spectrum of fluorescent light is not an evenly distributed one. It concentrates on certain colors—because of some fundamental theory of physics that I do not intend to discuss here (phew!).

EXERCISE: THE WHITE BALANCE PULL-DOWN

1. Among the companion files, locate "photobooth.dng" and open it into Photoshop. You will be in the Camera Raw dialog box.

2. Work along through the following discussions.

Here we have a shot of two newlyweds in a photo booth that was featured at their fancy reception. This photo booth was lit with a fluorescent light. Look at **image 4-47**; their faces look rather green—as if they had way too much to drink (but I can attest that they practiced moderation!).

We will fix it in Camera Raw. One thing we haven't looked at yet is the White Balance pull-down above the Temperature slider. Let's give it a try. The default value of the pull-down

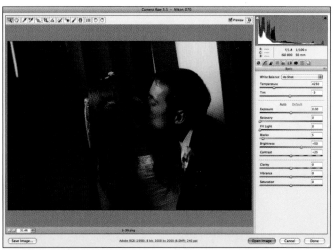

Image 4-47. Photo booths are fun, but their lighting is rather greenish.

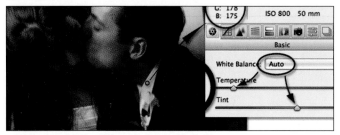

Image 4-48. The White Balance pull-down set to Auto.

is As Shot. This means the Temperature and Tint sliders are, by default, set to whatever the camera was set to.

Click on the White Balance pull-down and choose Auto. As you can see in **image 4-48**, the colors shift toward cyan. Check out the areas that are supposed to be white—like the collar of the groom's shirt. It does not look quite white to my eyes.

I want to introduce to you another tool for evaluating colors. So far we have been relying on our naked eyes and the (presumed) accuracy of our monitors. We can certainly use some objective data to reaffirm those subjective observations. Let me direct your attention to the values displayed below the left side of the histogram. You can refer to **image 4-47** to learn where they are. In **image 4-48** you can see how they change with our adjustments.

The three values (for R, G and B) are the gray levels of the three channels. Back in chapter 2, we discussed how a color image is assembled from three black & white images that represent how much red, green, and blue we need at each part of the image. These black & white images are described with gray levels having values from 0 to 255; 0 is black, while 255 is white.

Move your cursor to the collar of the groom's shirt. The RGB value display will be around R162, G178, B175. A neutral color (like white) is formed when these values are all equal. Therefore, this reading confirms our earlier observation: there is too much cyan in the image. (There are higher green and blue levels, and green plus blue makes cyan.)

Why does the automatic white balance setting lead to this? The orange curtain of the photo booth is the culprit. While this image has mostly neutral colors, the curtain dominates. The automatic white balance setting, upon seeing the abundant orange tone, decided to shift the image toward cyan to balance it. So is the automatic setting smart? I don't think so—and I hope you agree with me. As a matter of fact, I never use it either in Camera Raw or on my camera. After all, a perfect "average" is not what I look for. Kiss that auto white balance goodbye, my dear readers!

Let's click on the White Balance pull-down and try the Fluorescent setting. As you can see in **image 4-49**, the skin tone now looks much more pleasant. Place the cursor around the same spot on the groom's collar and you will get values in the neighborhood of R175, G175, B154. It is heavier on red and green, which makes yellow. It is not neutral, but it is much more pleasant than cyan.

As for my personal taste, I tend to apply a warmer (more yellow and red) tone to portraits. It makes people look healthy. So the Fluorescent setting is good. Look at the Tint slider. The +21 value here is responsible for taking that unpleasant greenness away.

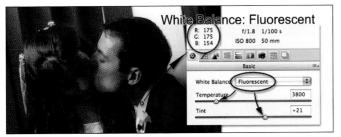

Image 4-49. The White Balance pull-down set to Fluorescent.

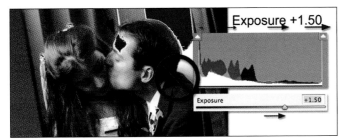

Image 4-50. The Exposure slider set to +1.50.

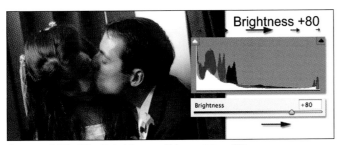

Image 4-51. The Brightness slider set to +80.

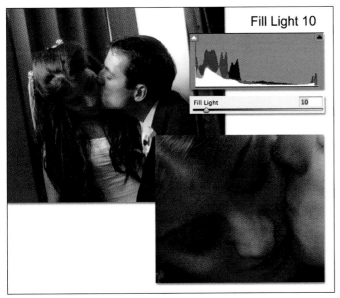

Image 4-52. Adjusting the Fill Light slider to 10 reveals a problem: noise on the bride's face.

We will refine the brightness to complete the work. While it is obvious that we need to increase the brightness, a look at the right edge of the histogram suggests the highlights are already pushing the white point, which means increasing the Exposure slider will very quickly produce hot spots. Try it and you will see what I mean (**image 4-50**).

Return the Exposure slider back to 0. We will use the Brightness slider instead. As demonstrated earlier in this chapter, the Brightness slider displaces primarily the middle part of the histogram; the highlight and shadow are barely affected. This characteristic makes it a better adjustment in this case, in which we need to avoid blowing out the already-quite-bright highlights. Drag the Brightness slider to +80 and you will see a pretty, nice brightness—without creating any hot spots at all (**image 4-51**).

As you can see this, this is a candid shot, so the lighting was not carefully controlled. As a result, the light on the bride's face was not quite sufficient. We can use the Fill Light slider to fix this. Drag the Fill Light slider to the right to a value of 10. The shadowy areas are brightened.

But wait! This might not be a good idea. Go to the lower left corner, then click on the Zoom Level pull-down. Choose 100 percent. Press and hold the Space bar to temporarily activate the Pan tool and pan the image to the bride's face. We have a problem: her face has a lot of noise (**image 4-52**).

Eliminating the noise generated by a digital camera's sensor is one of the last technological frontiers. Like the "white noise" produced by audio equipment, which becomes very prominent when the music is quiet and the volume is high, the noise produced by digital cameras can be well-hidden in the midtone and highlight areas of an image. Visible noise lurks in the shadows. If the shadows are pushed against the black point, or are clipped, noise is harder to see. In our case, unfortunately, increasing the Fill Light means the shadow areas are brightened—and the noise pops out.

What can we do to reduce the noise? We will discuss this topic in the next chapter. There will also be lots of discussion about noise in appendix B.

CURVES IMPROVE THE LOOK

We all know curves can make your figure look great—but curves can also make images look better in Camera Raw. While you need to go to the gym to refine the former curves, I'll show you how to work on the latter while remaining comfortably seated. The latter does not improve the former though, so don't cancel your gym membership. If you are

seeking virtual solutions for the bodily curves, look for my future Photoshop book about digital plastic surgery. (Okay, this whole paragraph is a joke . . . except the future book teaser.) If you are not comfortable working with tone curves, flip back to chapters 3 and 4 to familiarize yourself.

EXERCISE: THREE METHODS FOR USING TONE CURVES

1. Among the downloaded companion files, open "houtsonskyline.dng."

2. Work along with the following discussions.

In **image 4-53** you see an image of the Houston skyline opened into Camera Raw. This is a shot from, arguably, the best spot to view the city's awesome skyline. Standing on the top of a pyramid, I also captured a few park visitors.

Examining the image, you will see a few things left to be desired. First, the highlights are not brilliant enough. The scene might look more dramatic if we increased the contrast. We will do all the adjustment with tone curves this time.

Direct your attention to the row of tabs located under the histogram. To get to the Tone Curve panel, hover your cursor over the second tab from the left; the tool tips will indicate "Tone Curves." Click on this tab and you will see the Tone Curves panel (**image 4-54**).

There are three ways to manipulate tone curves in Camera Raw. I will demonstrate my least favorite way first. From chapter 3, you might recall that to increase contrast, we will need a curve with an "S" shape. The reason is simple; it will make the highlights brighter and the shadows darker—hence, higher contrast.

By default we are in the Parametric subtab under the Tone Curve tab. In here you see four sliders: Highlights, Lights, Darks, and Shadows. These control different parts of the curve: the right quarter, the right half, the left half, and the left quarter, respectively. Drag the sliders around and you will see how they impact the curve.

Because we are going to increase the brilliance of the highlights first, it is a good idea to turn on the Highlight Clipping Warning so we can keep an eye on any emerging hot spots. If it is not already on (as indicated by a white outline around the square that houses the triangle), click on the little triangle at the top right corner of the histogram.

Drag the Lights slider to the right until the value is +25. As you can see in **image 4-55**, the highlight is much strengthened in the preview. Look at the curve. The right

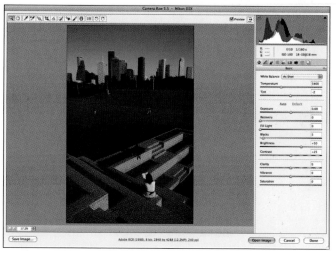

Image 4-53. Houston skyline image opened into Camera Raw.

Image 4-54. The Tone Curve panel with the Parametric subtab selected.

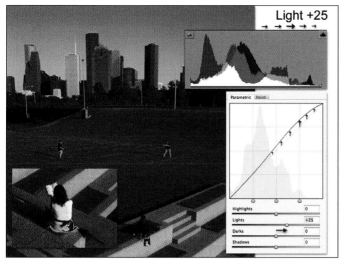

Image 4-55. The Light slider adjusted to +25.

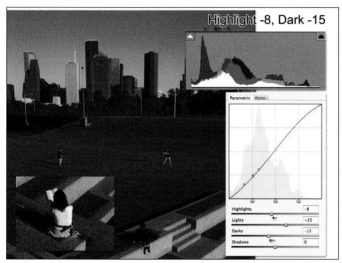

Image 4-56. The Highlight slider adjusted to -8 and the Dark slider set to -15.

half of the curve is pushed upward but maintains a smooth shape. Because the smoothness is maintained, the effect spills into the darker side.

Using the Tone Curve panel does not mean we are abandoning the good old histogram. As you drag the Light slider, notice how the histogram moves. If you project the curve vertically, any upward move of the curve results in the histogram moving to the right. The more the curves goes up, the more the histogram goes to the right.

Notice that some hot spots have emerged on the book reader's clothes. This is not a big deal; the area is small. For the sake of demonstration, however, we will fix it by dragging the Highlights slider to the left to -8. Some hot spots remain but they are very tiny. Attempting to get rid of them completely has a drawback: it will compromise the brilliant highlight we have just created. So let's not do that.

To complete our "S" curve for higher contrast, we will drag the Darks slider to the left until the value is -15 (**image 4-56**). With this move, the image looks more dramatic. The sky has a beautiful gradient and the evening light reveals itself with a stronger effect.

This is actually my least favored way to adjust the curves in an image, so let's undo what we did. But wait! Don't click on that Cancel button yet! If you hit the Cancel button (in Photoshop or Camera Raw), you'll be kicked out of the dialog box. We do not want out, we just want to undo what we did in this session (since the dialog box was opened). To do this, press and hold Alt/Opt. This will transform the Cancel button into a Reset button. Click on Reset and everything you did just now will be undone. Remember this useful shortcut!

Let's try a better way to manipulate the tone curves. Click on the Point subtab. Now the Tone Curve panel should look like **image 4-57**. Under the Point subtab, the tone curves can be reshaped with direct clicks and drags.

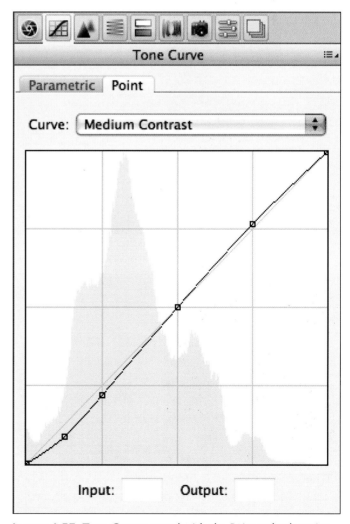

Image 4-57. Tone Curves panel with the Point subtab active.

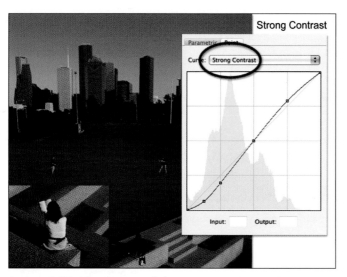

Image 4-58. The Curve pull-down is set to Strong Contrast.

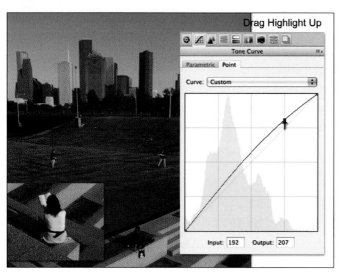

Image 4-59. Dragging the highlight up.

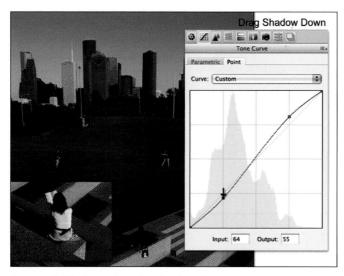

Image 4-60. Dragging the shadow down.

By default, the Medium Contrast setting is applied. This means that all RAW images are opened with this curve. Good to know, isn't it? As you can see, the Medium Contrast setting sports a mild "S" curve. Click on the Curve pull-down and choose Strong Contrast. In **image 4-58**, you can see that the curve now has a stronger adjustment on the darker side, which gives an overall darker tone. This is not exactly what we are looking for.

Click on the Curve pull-down again; this time, choose Linear. We have a totally straight slope now. You might also notice that there are no anchor points; in order to reshape the tone curve, we will first place some anchor points. Move your cursor over the curve and you will see coordinates pop up in the Input and Output fields. Place the cursor where the coordinates read 192 and 192 (which means the gray level is currently 192). Click to place an anchor. Now, drag the anchor upward until the Output value reads around 207—so the original gray level of 192 is now mapped to 207, a little brighter. Refer to **image 4-59** for the difference you would see in the Preview.

Now go to the where the curve meets the second vertical line from the left. This is the center of the darker side. Click and place an anchor. Click on the anchor and drag it downward until the output value is around 55. As you can see in **image 4-60**, the curve now displays a moderate "S" shape and the Preview indicates a similar result to our first attempt.

Press and hold Alt/Opt, then click on the Reset button. Let's try the third way to manipulate the tone curve. Above the Preview, click on the fifth button from the left. The button looks like **image 4-61**. This is the icon for the Targeted Adjustment tool.

Image 4-61. The Targeted Adjustment tool.

Before you do anything with this tool, note that the Targeted Adjustment tool's impact on the tone curve is only displayed in the Parametric subtab, so click on that if you are not already there.

The Targeted Adjustment tool lets you designate any spot on the Preview, then indicate the amount of adjustment you want on that spot. Then, it shows you the degree of adjustment you have applied on the curve.

Move the cursor to the upper part of the sky where it is darker. We want it to be even darker. When you click and hold, you will see the cursor turn into four-way arrows. Dragging it downward slowly, you will notice that the sky turns darker and the left side of the curve sinks lower. Stop

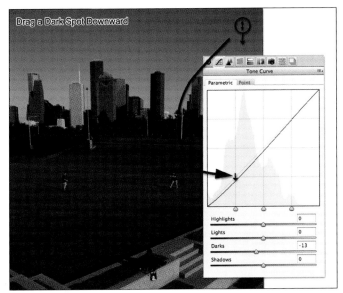

Image 4-62. *The Targeted Adjustment tool used on the Preview to darken an area of the sky.*

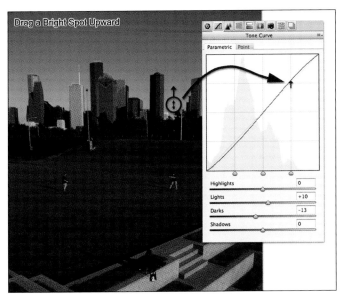

Image 4-63. *The Targeted Adjustment tool used on the Preview to lighten an area of the sky.*

at the point where the left side of the curve becomes similar to our previous attempts (**image 4-62**).

Now put the cursor at a bright spot in the sky. A spot between the brown building and the shiny glassy building will be ideal. Click and drag like last time, but this time pull up and watch the highlights in the Preview grow—and the right side of the curve go upward (**image 4-63**). Stop when the result looks right to you.

TONE CURVES *vs.* HISTOGRAMS

What we did to the Houston skyline image using the Tone Curve panel is also totally achievable using the sliders under

the Basic tab. So the choice to use one or another is purely a personal one. All of the adjustments made with the exposure sliders can be done with tone curves adjustments—but the reverse is not true, as will be explained in the following exercise.

EXERCISE: SOME CRAZY TONE CURVES

1. Continue to use the "houstonskyline.dng" file.
2. Work along with the following discussions.

In the Point tab of the Tone Curve panel, we can place as many anchor points as we want. (If there is a limit, I am not aware of it—and I truly don't care. You'd have to be nuts to place more than six anchors on the curve . . . which is exactly what I am about to do!) Placing several anchor points lets us tweak the curve into a pretty complicated shape.

For the purpose of enhancing and adjustment, it rarely becomes necessary to turn the curve into a roller-coaster track. If you want to be playful, however, it is possible turn the image into something quite dramatic. Play with it and you will see. I am showing you a few of my favorites here in **images 4-64** through **4-67**.

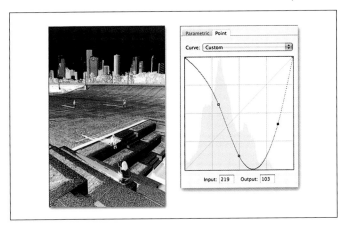

Image 4-64. *"E.T.'s View" tone curve.*

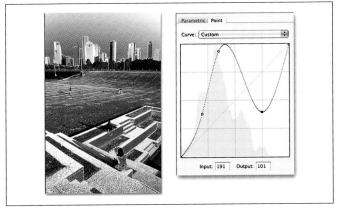

Image 4-65. *"Pastel Wonderland" tone curve.*

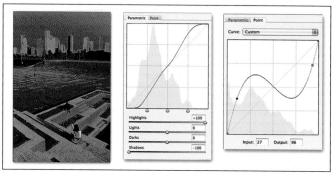

Image 4-66. "Depression" tone curve.

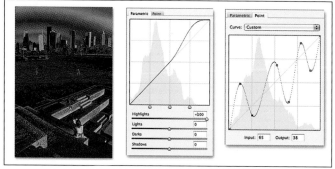

Image 4-67. "Roller Coaster" tone curve.

In "E.T.'s View," the curve produces a half-positive and half-negative image. The overall high key in "Pastel Wonderland" produces saturated but bright color. The depressive mood of "Depression" is made by the partial inversion of the curve and overall low contrast. Notice that the two curves work simultaneously on the image (which is again, crazy). The explosion of colors in "Roller Coaster" was caused by the, yes, roller coaster ride on the curve. See if you can get crazier than these.

An important note, here: none of these effects are achievable by manipulating the histogram with the sliders under the Basic tab. Compared to the sliders, tone curve adjustments are much more able to target a small range of brightness and apply changes selectively.

CAMERA RAW OR PHOTOSHOP?

The inquisitive reader might have a question at this point. While the Camera Raw interface is very user-friendly, the tasks we performed in this chapter seem doable in Photoshop, too. So why should we choose Camera Raw over Photoshop?

The answer lies in the name: Camera Raw deals with "raw" material. If we are cooking, there is a lot more we can do when we start from scratch. A seasoned, semi-cooked food will leave us fewer options. Working in Camera Raw is like cooking from scratch. Consequentially, working in RAW

usually results in less loss of quality, which is a common issue when excessive adjustments are applied.

Now, it's time to apply what you have learned in this chapter to some challenges.

QUIZ 2 **MAKE THESE HAPPEN!**
Among the downloaded companion files, find the following images. Your task is to manipulate the images in Camera Raw so that the original images turn into the final images. There is no "correct" answer for these tasks. Your goal is to make the original images look as close to the target images as possible. When you are done, check the official answers in appendix D and compare them to your own.

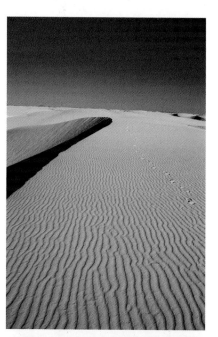

Image 4-68.
The original image (file name: "sanddunes.dng").

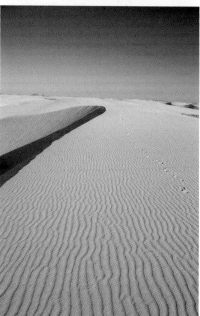

Image 4-69. The target image.

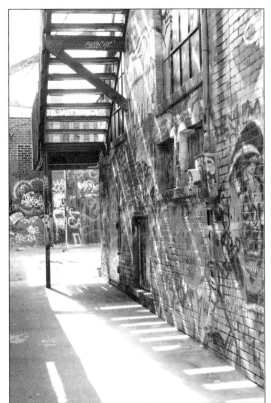

Image 4-72. The original image (file name: "sunset.dng"). *Image 4-73. The target image.*

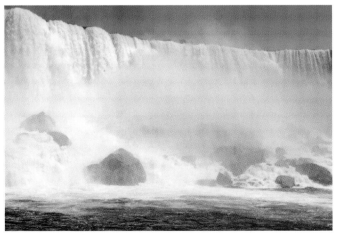

Image 4-74. The original image (file name: "waterfall.dng"). *Image 4-75. The target image.*

5. Finessing Camera Raw

The last chapter should have impressed you with Camera Raw's ability to improve an image with just a set of sliders. While these sliders are versatile enough to handle many situations, sometimes imperfections are beyond the act of pulling and pushing. In this chapter, we will examine techniques for finessing images in Camera Raw. We are talking about applying delicate adjustments to RAW images. As always, we will learn by studying some real-life examples.

DELIVER YOUR WORKS AS RAW FILES

Since the quality and versatility of RAW images are unsurpassable, it is likely that art directors will begin requiring work be delivered in this format. I would not be surprised if stock-photo agencies also start accepting RAW files in a few years. One thing that will make this possible in the future is the ever-increasing Internet bandwidth. Can you imagine transferring even a JPG through a dial-up connection? Nowadays, sending a JPG through broadband connections is a breeze. In a few years, sending a RAW could be just the same. Progress and infrastructure have to go hand in hand.

If my prophecy is correct, we will all have to learn to refine our work as much as we can in Camera Raw, then save our files in the DNG format before we deliver them. In this case, the skills you are about to learn in this chapter will complete your training. Are you ready to move on from learning about the Force to mastering advanced light-saber techniques, my Jedi apprentice?

COLOR ADJUSTMENTS WITH A YARDSTICK: THE WHITE BALANCE TOOL

We are going to start by elaborating on the adjustment skills learned in the last chapter. What you learned about color adjustment was all based on your judgement. I consider color adjustment to be a matter of taste, so there is usually no "correct" answer. However, sometimes you may want to be a little more absolute. Let's learn how to be absolute about white balance in Camera Raw.

EXERCISE: USING THE WHITE BALANCE POINT
1. From the downloaded companion files, find "houstonskyline2.dng" and open it into Camera Raw.
2. Work along with the following discussions.

Image 5-1 shows you the skyline in Camera Raw. Let's do a quick fix by increasing the Exposure slider to +0.50. The shot was made during the sunset hour so the color temperature

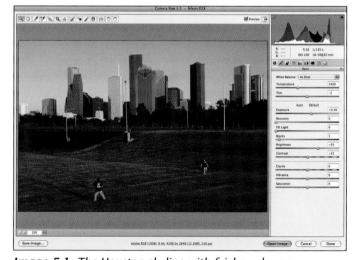

Image 5-1. The Houston skyline with frisbee players.

Image 5-2. The White Balance tool icon. *Image 5-3. The Color Sampler tool icon.*

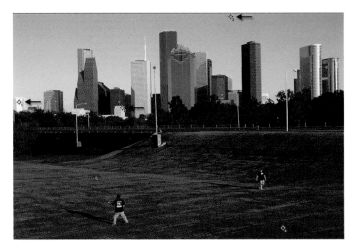

Image 5-4. Place the color sampling points at these spots.

Image 5-5. Make sure the sampling point is on the off-white wall, not the bluish window.

was low. I like the warm look—but if we want to see the "true" colors of the buildings, we could use some help from the White Balance tool (**image 5-2**). First, though, let's use the Color Sampler tool to evaluate the colors in the image (**image 5-3**).

First let's place a few color sampling points. Click on the Color Sampler tool button to activate it. Then, click to place sampling points as indicated in **image 5-4**. Look above the Preview panel. Each of the sampled points now corresponds to the RGB readings of that spot. Zoom in to place point 1, as there are windows that should be blue; you don't want to put the point on these blue windows (**image 5-5**).

Click on the White Balance tool button to activate it. Now, we need to find a reference point that we know should be colorless. I know for a fact that the Lyric Center—the building where we choose to place sample point 1—is white. (Check it out on GoogleMaps if you want. It stands in Houston at the intersection of Prairie and Louisiana—and there is a cool sculpture in its plaza.) Currently, the RGB reading of that building is R253, G247, B221. (*Note:* The number on your point could be slightly different; the point you placed is unlikely to be exactly the same as mine.) There is clearly less blue than is required to make it white—thanks to the warm color of the late-afternoon light.

Place your cursor exactly at the center of point 1 and click. Now the reading of point 1 becomes R245, G245, B245.

It is now colorless. Strictly speaking, it is not white—white would read R255, G255, B255—but we do not want point 1 to be exactly white, because that might blow out some other parts of the image.

After this click, what you see should look like **image 5-6**. This looks much more like the colors you would expect during midday—except that the long shadows of the frisbee player contradict it. Notice the four sample points all reflect a similar change: more blue.

Now, let's click on the building where we placed point 2. Zooming in to this area you will see a classic-looking building with a clock. This is our good old Houston City Hall. The building has a cream color façade. If we force the cream exterior of city hall to be neutral by clicking our White

Image 5-6. How the image looks after sampling point 1 has been rendered neutral.

Image 5-7. How the image looks after sampling point 2 has been rendered neutral.

Balance tool on point 2, the whole image will be tinted with blue, as illustrated by **image 5-7**. Now, the Lyric Center looks blue, and the reading on point 1 (R240, G244, B249) confirms that.

For those of you who do studio work, you may place a gray card in the shot, then use the White Balance tool to force all colors out of the gray card. Once again, I am not a fan of color "accuracy." I adjust the colors as I like them, so my White Balance tool was covered with cobwebs until I demonstrated this technique to you just now. However, if you like the idea of a dependable reference, or if you have to present the color of the newest bikini top as accurately as possible, the White Balance tool could be your good friend. Or, you many choose to use this absolute adjustment as a starting point, then move on to add your personal flavor to the image.

LOCALIZING ADJUSTMENT: THE GRADUATED FILTER AND ADJUSTMENT BRUSH

So far all of our adjustment efforts have been applied to the whole image. Sometimes, however, we have problems that call for more localized adjustments. The founding fathers of our nation faced the same issue; that's why we have a constitution for the whole country and we have independent state laws. Wisdom for Photoshop and wisdom for political systems can be quite similar. Surprised?

EXERCISE: CUT THE HAZE

1. From the downloaded companion files, find "banff.dng" and open it into Camera Raw.
2. Work along with the following discussions.

Image 5-8 is a shot of the grand Canadian Rockies at Banff. The downloaded file has already been adjusted to increase the contrast. The low contrast is due to the haze between where I stood and the mountain. Although the condition wasn't bad, I was shooting through a thick layer of air—zoom in to the trees on the rocky surface and you will appreciate the scale of this scene.

Particles in the air scatter blue light, giving the image a significant shift towards blue. To counteract this, we can pull the Temperature slider to the right to around 6400K.

Look at **image 5-9**. It appears that our Temperature adjustment has fixed only the right side of the mountain; the left side is still bluish. How did this happen? Clearly, the mountain to the left lies even further from the camera.

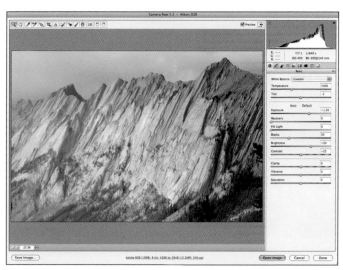

Image 5-8. *An image of the Canadian Rockies at Banff, opened into Camera Raw.*

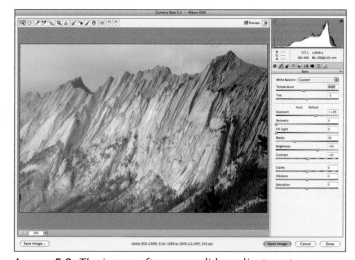

Image 5-9. *The image after some slider adjustments.*

There is more air and more scattering of blue light, so more adjustment is required.

What we need is a gradual, incremental color-temperature compensation toward the left. The Graduated Filter comes to mind for this. First, locate the button (above the Preview panel) shown in **image 5-10**. Click on it to activate the Graduated Filter.

Image 5-10. *The Graduated Filter icon.*

What you see now on the right side of the Camera Raw dialog box (**image 5-11**) is a subset of the adjustment tools under the Basic tab, which we dealt with in the previous chapters. The adjustments you set here will be applied to the full-power end of the Graduated Filter.

We will need to designate the starting and ending point of the gradient. One awkward thing is that we have to set some

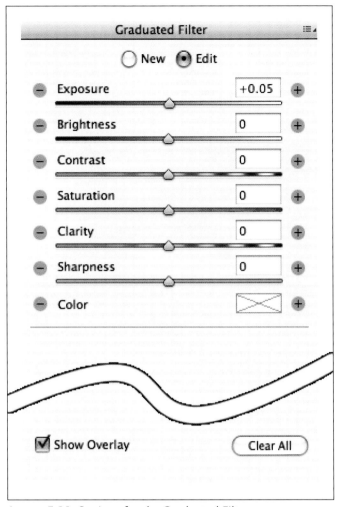

Image 5-11. Settings for the Graduated Filter.

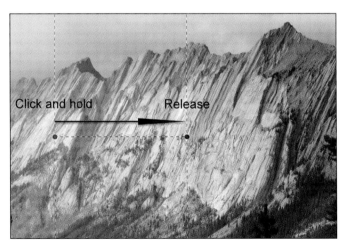

Image 5-12. Where to click and hold and release the Graduated Filter.

effect first—before we can place the gradient. You will see, at the end of the demo, that this is rather counterintuitive.

So we will just do a harmless +0.05 on the Exposure slider. We will apply the adjustment that is actually needed after the gradient is placed. Look at the image. The blue

haze starts to appear around the middle of the image and gradually increases toward the left. Then it remains about the same at the left one-fifth of the width.

With your Graduated Filter active, click and hold on a spot one-fifth of the width from the left, then drag to the right to the middle of the image, keeping the drag horizontal, and let go. Now, the Preview image will look like **image 5-12**.

The red circle and the red dotted line denote the "no effect" end of the gradient. Then the power of the effect starts to increase toward the other end. At the end of the green circle and the green dotted line, the effect comes to full power. Beyond the green line, it is applied at full power.

Now we will fix the color. Click on the box to the right of the Color slider (currently it has a cross on it, meaning "no effect"). The Color Picker dialog box pops up.

At first glance, this dialog box looks a bit puzzling—but it's actually simple. Moving horizontally on the bar of rainbow color lets you choose the color to shift to. Moving vertically lets you choose how much to shift (at the bottom means no shifting; at the top means shifting a lot).

We know our problem is too much blue. So we will add yellow to balance it (reread chapter 3 if you don't know why yellow will cancel blue). First, click and drag the color point (the small box in the rainbow area) over to the pure yellow area, keeping it at the bottom of the bar. Click to set the pick, as seen in **image 5-13**. You can see the Hue says 60. (*Note:* The number is in the unit of degrees. If you check out the color wheel [**image 3-6**], you can see that going from the top of the color wheel counterclockwise 60 degrees brings you to pure yellow.)

Leaving the color point at the bottom of the window means we are not adding any effect. We will now click and

Image 5-13. The Color Picker dialog box is set to Hue 60, pure yellow.

Image 5-14. In the Color Picker, increase the Saturation to 20.

Image 5-15. In the Color Picker, the Hue is shifted to 40, adding some red.

drag the box upward, slowly, and observe the effect in the Preview panel. I find the left extremity of the mountain appears to be of a similar color to the right half when the Saturation value reads 20 (**image 5-14**). You may also use the Saturation slider in lieu of the vertical movement. Click OK to dismiss the Color Picker dialog box. Uncheck the Show Overlay box at the lower right corner of the Preview to get rid of the gradient marker, allowing you to see the result better.

At this point, I find the left side of the mountain to be a little bit tinted with green. But now comes the best part of the Graduated Filter: You can readjust the filter setting after the gradient is placed. In this case, now that we know our initial assessment to use pure yellow to fix the problem did not entirely hit the spot, we can fine-tune the setting and observe the difference. Double click the box to the right of Color again and bring up the Color Picker dialog box. Look at the spectrum of colors. Our setting of pure yellow is right

in the vicinity of green. So to reduce green, we can drag our picker away from green toward the left. I find that when the picker is at Hue 40, the color of the mountain on the left best resembles that on the right (**image 5-15**).

Now, back to my complaint regarding this tool's counter-intuitive design: you can clearly see that the adjustment after the gradient is placed matters more than your initial guesstimation. Therefore, the requirement to have an adjustment setting before placing the gradient seems rather unnecessary. (Hear me, Adobe?)

Sometimes the problematic spots are not presented in a gradient pattern. We will then turn to the Adjustment Brush for help.

EXERCISE: SPOT TOUCHUP WITH THE ADJUSTMENT BRUSH

1. From the downloaded companion files, find "bride.dng" and open it into Camera Raw.

2. Work along with the following discussions.

"Bride.dng" is a candid shot of a beautiful bride summoning all the single ladies to the bouquet toss. When this image was created, the bride happened to be standing under a spotlight—a low color temperature source. As a result, her skin tone appears very yellowish in some spots, less yellowish in other spots. This kind of uneven lighting always poses a challenge. In **image 5-16,** the tighter view lets us assess

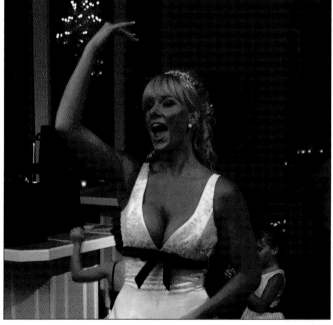

Image 5-16. A zoomed-in view of our image reveals the uneven skin-tone problems.

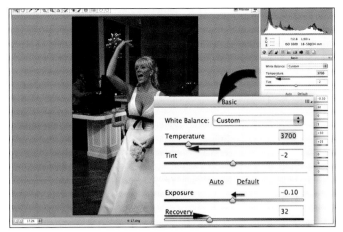

Image 5-17. A global fix is initially applied to the image (Temperature 3700, Exposure –0.1, Recovery 32).

the problem. You can clearly see that the yellowish spotlight coming from her left—so all of the parts of her facing that side carry more yellow.

The first step is to apply a global fix to shotgun the overall white balance. The spotlit areas will stand out at that moment, but we will shoot them down with the Adjustment Brush. The global fix is illustrated in **image 5-17**. The Exposure and Recovery sliders were applied, while attempting to eliminate the hot spots indicated by the Highlight Clipping Warning. As anticipated, the yellowness on the skin stands out. You can zoom in to see the details better.

Image 5-18. The Adjustment Brush tool icon.

Let's pick up the Adjustment Brush by clicking on its button (**image 5-18**). When you move your cursor onto the Preview image, you will see a rather complicated cursor (**image 5-19**). Let's examine it. The inner circle denotes the

range of solid brush. Within this circle, the brush is applied at full power. The ring area between the inner and outer circle is a graduated zone (the feather area); the effect goes from full power at the inner circle and gradually loses power. At the outer circle, the power drops to half. Outside the outer circle, it continues to drop off to nothing.

Keep in mind that Adjustment Brush is just like all the brushes in Photoshop, so all you know about how to set a brush in Photoshop should apply. Notice that I used the word "should." There is a group of sliders right under the adjustment settings; these look nicely laid out, but do not use them. Unfortunately, when the cursor is used to drag these sliders, you can't see the circular cursor anymore. This leads to a tedious process of moving the cursor back and forth between the sliders and the Preview—it's terribly inefficient.

You are better off using the shortcut keys instead. The [and] keys make the brush larger and smaller, respectively. When either of these keys is pressed, the concentric circles indicate the current brush size. Notice that the graduated zone remains proportional to the size of the brush. To adjust the width of the graduated zone (the feathered area), use Shift+[and Shift+], which will make the zone smaller and larger, respectively. (*Note:* Readers familiar with the shortcut keys for the Brush tool in Photoshop might wonder if that's a typo—but it's not. These Camera Raw shortcuts are opposite the brush hardness shortcuts in Photoshop. Why? You'll have to ask the Photoshop team at Adobe!) To be sure there is no misunderstanding, the shortcuts are illustrated in **image 5-20**.

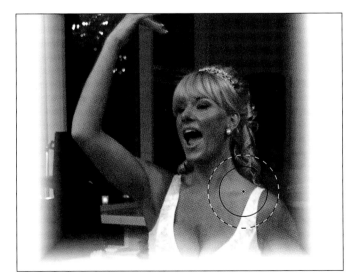

Image 5-19. The Adjustment Brush tool icon and its cursor.

Image 5-20. Shortcuts for the Adjustment Brush tool.

Image 5-21. The brush size and strokes.

Image 5-22. Bring up the Color Picker and set it as shown.

Image 5-23. Hover the cursor over the Pin to see the coverage of the strokes.

Now that we know how to set the brush, let's use it. Be warned: The task we are about to embark upon is rather delicate. It takes patience and close observation. To make sure your work covers the fine details, it is highly recommended that you zoom in and work on small areas. For the sake of demonstration, I will just cover the face and shoulder area.

Zoom in to the face and shoulder area and choose the Adjustment Brush. Use the shortcut key as explained earlier to adjust the size and feathering of the brush until it looks like the cursor in **image 5-21**. Then, click on the box to the right of Color in the Adjustment Brush settings. Set it as indicated in **image 5-22**. Click OK to accept the setting and dismiss the Color Picker dialog box.

Click and paint in paths as indicated in **image 5-21**. As soon as you make the first path, the radio button at the top of the Adjustment Brush panel automatically switches to Add. This indicates that you will be adding strokes using the same brush, as we are doing here.

After all the strokes in **image 5-21** are taken care of, click on the box to the right of Color to bring up the Color Picker dialog box. Set it as illustrated in **image 5-22**. We are using extra blue to counter the excessive yellow. When you are done, you should notice some very subtle change of color where we painted. To observe the fine difference, check and uncheck the Preview box above the Preview panel.

At this time there should be a Pin attached to the spot where you started the painting. If there is none, check the Show Pins box at the bottom of the Adjustment Brush panel. With this Pin visible, you can conveniently review where the brush strokes are by placing the cursor over it, as shown in **image 5-23**. The painted area is indicated with a foggy indicator. Is overpainting on the background a problem? Not really; in this case, the objects in the background are rather colorless, so the adjustment has little effect on them.

The image is improved, but it's not perfect. Some spots have a more severe yellow shift because the spotlight was stronger there. This includes the left side of her face, near her ear and down the left side of her neck, and the left edge of her left shoulder.

We need to apply another pass with the Adjustment Brush set for a stronger effect. The plan is to reduce the size of the brush and apply more strokes on the aforementioned areas.

Image 5-24. Setting the Color Picker for a second Adjustment Brush stroke.

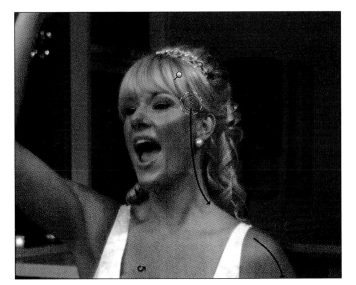

Image 5-25. The brush size and strokes for the second application of the Adjustment Brush.

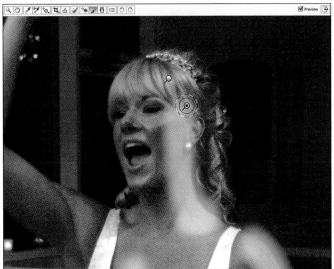

Image 5-26. Hover the cursor over the Pin to see the coverage of the strokes in the second application.

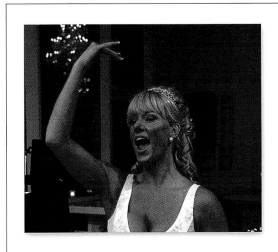

Image 5-27. Compare the before and after images.

A very important thing to know here is that Adjustment Brush's effects do not accumulate. Therefore, if we keep the same settings and apply more strokes over the area we brushed just now, nothing is going to change.

It is very important now to change the radio buttons at the top of the Adjustment Brush panel to New—so we do not overwrite the previous adjustments to the targeted areas. Now, let's bring up the Color Picker dialog box by clicking on the box to the right of Color again. We will increase the Saturation to 40, as indicated in **image 5-24**. Click OK to accept the change. Reduce the brush size and apply strokes as illustrated in **image 5-25**.

When you are done, you can check the strokes using the same method described previously. **Image 5-26** shows where the strokes are. **Image 5-27** provides a before and after comparison.

We are done adjusting the face area. You can apply the same procedures to the other areas to complete the work.

RETOUCHING: CLONING AND HEALING

Readers of this book are very likely to have mastered the skill of cloning and healing within Photoshop—or at least have some inkling about it. These tricks that remove blemishes, cover tattoos, or add a few pieces of clouds, can also be done inside Camera Raw. (In case you are unfamiliar with cloning and healing [which I hope is not the case], cloning is a process that duplicates data from a source area of the image and copies it over a target area of the image. Healing does the same thing, but goes one step farther: it blends the duplicated image data with the new surroundings.)

Why should we do this in Camera Raw when we can do it in Photoshop? One answer I can toss back at you is the

ability to deliver a fully processed image, ready to be used, in the DNG format. With the introduction of cloning and healing (grouped as functions of the Spot Removal tool), the idea of delivering images as RAW files is even more doable. I am even more confident in making this prophecy: one day, art directors and design people are going to request DNG files instead of JPG files.

EXERCISE: GETTING RID OF THE ANNOYING SENSOR DUST MARKS

1. Find image "milkcartons.dng" from the downloaded files and open it into Camera Raw.
2. Work along with the following discussions.

Sensor dust drives me nuts. I am sure that many of my fellow photographers feel the same way. The sensors of digital cameras naturally generate static, which attracts dust. My tendency to change my mind about which lens to use does not help, because the lens-changing process brings dust into the chamber. My sincere advice to readers is not to try to clean the sensor yourself. Sensors are ten times more fragile than lenses, so give this job to the professionals. It's better to have an underweight wallet than a camera with impaired vision.

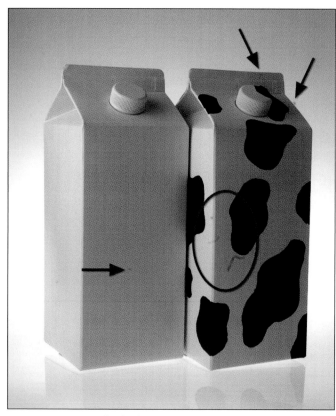

Image 5-28. A still life shot with many sensor dust marks.

In between the visits to the pros to clean up the sensor, we have to live with the dust. This means that touching out dust spots is a necessary evil. Let's see how we can do that in Camera Raw.

Image 5-28 is a still life shot for my "cow and soy milk" project—and my visit to the pro for a cleaning is, obviously, overdue. The dust marks are indicated with red markers.

You might notice some exposure and crop adjustments have already been made on this image; keep them. Zoom in to the problematic areas to check them out. Let's start with an easy one: the dust marked by the arrow farthest to the left in **image 5-28**.

Activate the Spot Removal tool as indicated in **image 5-29**. Direct your attention to the right, where you can see the settings for the tool. Every time you start using this tool for the first time in a Camera Raw session, the brush size is set to 1, so your cursor only shows a cross. Notice that Heal is the default setting. The the other option would be Clone—but we need Heal, in this case. Keep the Opacity at 100 percent, because we do want the dust to completely disappear. Now, click and hold on the center of the dust spot and drag outward until the circle covers the dust mark. Release the click.

In a few seconds (be patient!), a red circle will pop up to indicate where Camera Raw "thinks" it can sample a source to cover the target area. This source are appears in the green circle (**image 5-30**). Most of time, Camera Raw can't pick a good source—but in this case, it would be hard to pick anything wrong, wouldn't it?

Now, let's move on to something more challenging—for us and for Camera Raw. Pan and zoom in on the dusk mark at the top right corner of the cow-patterned milk carton (**image 5-31**). To avoid the milk carton, it seems reasonable to cover this one with two circles, each one with a radius of 3. My first circle covers the top left side of the mark. Moments after I placed my red circle, the green circle was placed by Camera Raw (**image 5-32**).

If your Camera Raw did the same as mine, you might notice that the cloned image inside the red circle has some traces of lighter area to the lower left side. This is because the green circle was too close to the edge of the milk carton. To reposition the source, click and drag the green circle somewhere further from the milk carton. That trace of white is gone, as seen in **image 5-33**.

At this moment, the mark does not seem to be gone. This is because the Heal mechanism is blending to the mark that

hasn't been covered. So a second red circle of the same size is required to cover the whole dusky-toned image. Again, help Camera Raw choose a better source by dragging the green circle to the area indicated in **image 5-34**.

Let's examine the result by turning off these circles. Go to the lower right corner of the Camera Raw dialog box and uncheck Show Overlay. The result is obviously less than satisfactory; a dark mark still exists, as seen in **image 5-35**.

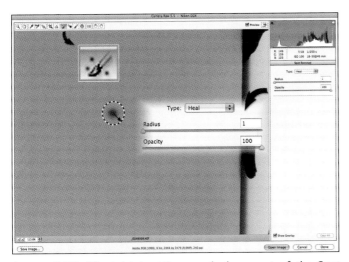

Image 5-29. The initial settings and placement of the Spot Removal tool.

Image 5-30. An automatic source selection made by Camera Raw.

Image 5-31. A more challenging case for the Spot Removal tool.

Image 5-32. The first target placement and automatic source selection.

Image 5-33. The source is manually repositioned.

Image 5-34. The second target placed and the source manually placed.

Image 5-35. The outcome, with the Overlay turned off, is not satisfactory.

Image 5-36. After removing the previous Spot Removal, the target now covers the whole dust spot and a corner of the milk carton.

Image 5-37. The automatic sourcing selection made by Camera RAW. Not wise.

Image 5-38. Manually (and carefully) placing the source so the edge of the milk carton is aligned.

We did cover that original mark with good sources didn't we? We sure did. The dark mark now is not the dust, it is the blending effect of the Heal setting at work. When the Heal setting blends data, it looks further than the immediate area that touches the circle. In our case, because the red circles are so close to the milk carton, it attempted to blend the cloned image to the carton, causing the area to turn dark.

What would be our solution to avoid this problem? We will clone the milk carton! Check the Show Overlay box and click on the circle, then hit Delete to get rid of our previous attempts. Now, create a larger red circle that covers the whole dust mark—naturally, the milk carton is included. See **image 5-36**.

What happens next? Of course! Camera Raw picks a bad source—as usual (**image 5-37**). I do, however, give this

Image 5-39. This is what happens when the source is too far from the target.

Images 5-40, 5-41, and 5-42. How the other dust marks are handled.

choice some credit, because the idea was right; some milk carton needs to be sourced. What we will do next is carefully drag the green circle around until the image inside the red circle indicates a perfect match. My attempt is shown in **image 5-38**.

There are two cautions here. First is that the refresh of the cloned image takes time, so wait it out. Second is that the slope of the milk carton is not straight; it is a very slight curve. This means that the source and the target should be as close to each other as possible or the angle of the slope will be off, as seen in **image 5-39**. (*Note:* Readers who have mastered the Clone Stamp tool in Photoshop might know it can rotate; Camera Raw's Spot Removal tool does not rotate.)

Using the same approach, other dust marks can be fixed (**images 5-40, 5-41**, and **5-42**). I am especially pleased with how **5-42** is done—cloning one cow pattern to another!

CROP AND STRAIGHTEN

Earlier on in this book I mentioned my intention not to make this book a boring manual that puts readers to sleep. Therefore, I have focused mainly on intriguing techniques that are both practical and inspirational. The title of this section certainly does not entirely fit into the criteria. Practical? That is for sure. Inspirational? Hardly. So let's briefly go over Crop and Straighten. I am sure all of my readers will find these processes extremely easy to handle.

There is actually one good reason to use Crop and Straighten in Camera Raw. At the beginning of this chapter I mentioned the possibility of delivering a retouched work in the form of DNG. Cropping and straightening would be rather essential for this purpose.

EXERCISE: WRONG LENS AND SHAKY HANDS

1. From the downloaded companion files, find "frisbee. dng" and open it into Camera Raw.
2. Work along with the following discussions.

At the introduction of this book, I made a point about the necessity of using Camera Raw by noting that inside every great photographer there is a tiny, not-so-great photographer. Here, I present my own tiny photographer at work.

In **image 5-43**, you see a frisbee player framed in a circular shadow. This is the result of a full-frame dSLR shooting through a DX-format lens, which is designed for a smaller sensor size. Why did I do this? I could tell you that I shot

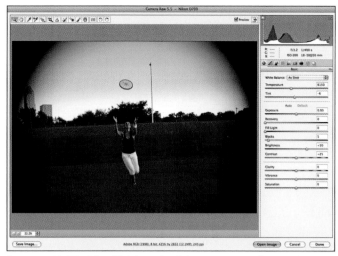

Images 5-43. *The "frisbee.dng" image opened into Camera Raw.*

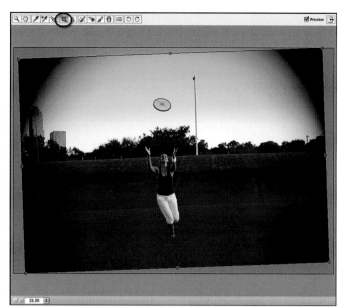

Image 5-46. *The default crop with the Crop tool ready.*

this on purpose for the demo, but I'd rather be honest with you and confess: I brought the wrong lens. The models were ready to throw the frisbee. What could I do? Shooting first and fixing it in Camera Raw later seemed to be a reasonable solution. It also avoided instant embarrassment.

Image 5-44. *The Straighten tool icon.*

We will pick up the Straighten tool first (**image 5-44**), since the horizon is rather crooked. Click on the horizon and pull along it, as indicated in **image 5-45**, then let go. Camera Raw places a rectangular crop on the preview with one side parallel to the line we dragged and the tool switches automatically to the Crop tool, as seen in **image 5-46**.

The next step should be very obvious: Drag around the handles of the crop box to your liking. I would do it like **image 5-47**. Voilà!

Image 5-47. *Reshape the crop with the handles.*

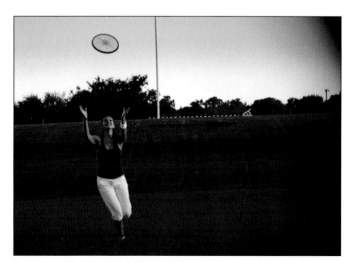

Image 5-45. *Click, hold, and drag the Straighten tool along the horizon.*

Image 5-48. *Click and hold the Crop tool icon to get this menu.*

Now, if we choose to open this image into Photoshop, it will be cropped accordingly. What if we want to clear the crop? To do this, click and hold the Crop tool button to trigger a pull-down menu. Then, choose Clear Crop, as seen in **image 5-48**.

Now that we have dealt with an easy Crop and Straighten task, let's move on to something more exciting.

PARADISE (AND TROUBLE IN PARADISE)

These great functions in Camera Raw give new meaning to the concept of nondestructive procedures: Photoshop operations that can be easily redone or undone. The milestones of nondestructive procedures were the introductions of Layers, Layer Masks, Layer Styles, and Smart Filters. For a deeper understanding of nondestructive procedures, I suggest reading my book *Creative Wedding Album Design with Adobe Photoshop* (also from Amherst Media), which covers the concept in greater detail.

Compare the Spot Removal tool to the Clone Stamp or Healing Brush tool in Photoshop. The latter two sample the sources and place the cloned data where you want it. However, the only way for you to change that later is to erase these steps and start over. On the other hand, the Spot Removal tool maintains a link between the source and the target, hence keeping them "alive." You may redo them as you wish.

Be warned though: any kind of dynamic settings require more computing power. Try implanting Crop, Graduated Filters, and many Spot Removals in a RAW image. The next time you open it, it will take a long time. This is your computer having its hands (or, rather, its RAM) full as it re-establishes all the fancy enhancements you put in there last time.

TO EXTEND THE RAW POWER

In order to make the additional nondestructive power of Camera Raw meaningful in your workflow, all of these great tools need to be kept handy when the images are saved as PSDs. To make this happen, we need to use Smart Objects. Read on to the next chapter to find out how.

QUIZ 3 | **ROCKY MOUNTAIN MAKEOVER**
Find the companion file "rockymountains.dng" and open it into Camera Raw, as indicated in **image 5-49**. This is another shot of the awesome Canadian Rocky Mountains at Banff. In a region known for its unpredictable weather, this scene presents a variety of conditions in a single shot.

There is room for improvement in this image. First is the cloudy sky; it could use a little more contrast and color. Second is the shadowy area on the mountain; the light there was more blue, causing an unappealing color shift. Third is the glacier; its highlights could be a little stronger. Your mission is to remedy these three problems. When you're done, check appendix D to see how I fixed the image and compare your process to mine.

Image 5-49. "Rockymountains.dng" opened into Camera Raw

6. Extending the RAW Power into Photoshop

SMART OBJECTS

The Smart Object function was introduced in Photoshop CS2. While the name seems to tickle our imagination, we immediately wonder how this object can make our lives easier by being "smart." The name really does a poor job of informing us what this function is about. As a matter of fact, there are many different types of Smart Objects, which makes the term confusing and misleading.

In most cases, Smart Objects should simply be viewed as foreign objects. By "foreign objects," I meant graphic elements (in the form of layers) that need to be edited by something other than Photoshop.

Fast-thinking readers might have guessed what I am arriving at: we can turn RAW images into Smart Objects, extending the power of Camera Raw into the workflow within Photoshop. Using this strategy, opening a RAW file into Photoshop for further work allows the versatile Camera Raw dialog box to remain accessible throughout the editing process.

The benefits? There are many: having access to the powerful Camera Raw software all the time while working in Photoshop; replacing Photoshop tasks with easier/more effective Camera Raw tasks; being able to apply Smart Filters; and, most important of all, making our work more nondestructive. We will cover all of the benefits (except Smart Filters, which are beyond the scope of this book).

OPEN RAW IMAGES INTO SMART OBJECTS EXERCISE: THE SECRET PASSAGE

1. From the downloaded companion files, find any DNG file and open it into Camera Raw.
2. Work along with the following discussions.

While you are in the Camera Raw dialog box, press and hold Shift and see what happens to the Open Image button. It now says Open Object instead (**image 6-1**).

Click on Open Object and let the image open into Photoshop. At a glance, the image does not look any different. But look closely at the top of the image, where the image name is displayed. Now the image name says "(image name) as Smart-Object–1". Do not overlook that "1"; I will point out its importance later. Now, turn your attention to the Layers palette. The layer for this image is not a background layer, it is a layer named with the name of the file. Its thumbnail is a symbol that denotes a Smart Object (**image 6-2**).

Image 6-1. Press and hold Shift to turn Open Image into Open Object.

Image 6-2. A Smart Object in the Layers palette.

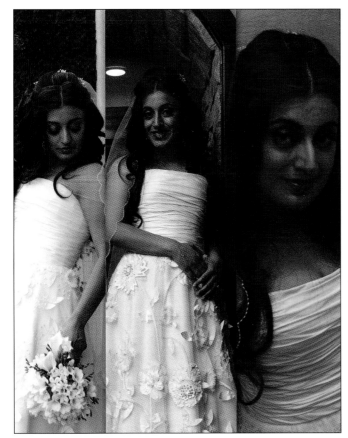

Image 6-3. Different lighting resulted in inconsistent skin tones.

Image 6-4. The layers for our example image.

These are just superficial differences. The core of this setup only shows itself when you double click on the image thumbnail in the Layers palette. Try that and you will be pleasantly surprised. Ta-da! The image opens back into the Camera Raw dialog box. This is full-blown Camera Raw without any missing functions. The only difference is at the lower right corner: now there are only Cancel and OK buttons. Try any adjustment you like and click OK to accept the change.

After a brief moment of data churning, the image is updated accordingly. Do I hear you cheering? If not, my dear reader, you need to know a Photoshop moment when you see one! Turning a Camera Raw image into a Smart Object adds a Jedi battalion into the already-powerful Jedi army of nondestructive procedures.

Now that we can invoke Camera Raw from a Photoshop image anytime we want, all the great features in Camera Raw become part of our nondestructive-procedure arsenal. New possibilities and more effective workflow systems are available because Camera Raw is now side-by-side with Layers and Layer Masks—and all the other goodies in Photoshop. In this chapter, we will explore some Camera Raw techniques that make even better sense when they join forces with Smart Objects.

SKIN-TONE CONSISTENCY REVISITED

We dealt with skin-tone consistency issues earlier on in this book, and Camera Raw proved itself a great tool. We will now work on a more complex case. In this one, three bridal images were made into a collage (**image 6-3**). These three shots were made under varied lighting conditions, so the skin tones and the color of the bridal gown went way off. Let's try to restore some consistency.

EXERCISE: SO MANY FACES, SO MANY COLORS
1. From the downloaded companion files, find "skintones. psd" and open it into Camera Raw.
2. Work along with the following discussions.

If you are following along, look at the Layers palette (**image 6-4**). This PSD file has three Smart Objects as three of its layers. There are other layers and layer styles in there to serve different purposes. (If you are curious about them, click the Layer Visibility icon to the left side of each layer to see what happens.)

Now, let's form a plan. To achieve the color consistency, we can use her pure white gown as a good reference. So we will use the White Balance tool to knock the color out of the gown. Then, we can use the Adjustment Brush to fine-tune the skin to our liking. All the time, we should be watching the skin tone to ensure it remains consistent.

In the Layers palette, double click on the thumbnail of the "left" layer to bring up the Camera Raw dialog box. Among the three images, this one has the most neutral white balance (again, I write "neutral" in lieu of "correct" to stress my belief that white balance is mostly a matter of taste). Pick up the White Balance tool by clicking on its button

Image 6-5. The White Balance tool icon.

(**image 6-5**). Now click on a spot on her dress, somewhere on the bright side of the torso (**image 6-6**). Once you do, you will see the Temperature and Tint being set to around 5250K and –7 (you could get different numbers if you do not click on exactly the same spot). Move your cursor to the point where you just clicked and you will find its RGB values are very even. In other words, it is quite colorless.

Keep in mind that even under seemingly soft daylight, these colors can still be uneven. This could be due to the reflection of a nearby object, or the difference between more direct sunlight and more shadowy sunlight. Looking at her dress, you will see slight variations in the color. If you click on different spots on the dress, you will get different Temperature and Tint settings, as indicated in **image 6-7**. This of course, will affect the look of the image. I will settle for the first attempt. Click OK to accept the changes if you haven't done so.

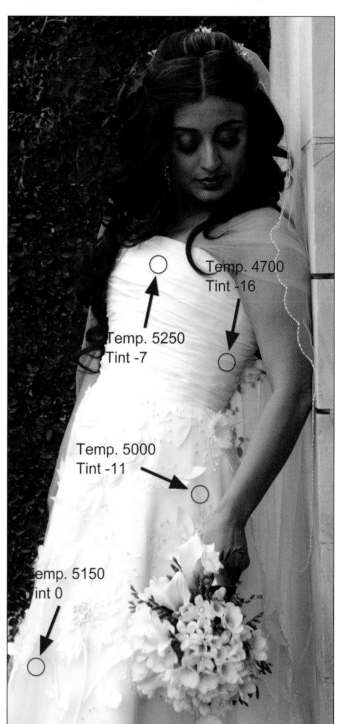

Image 6-7. Use the White Balance tool to click on different spots on the dress. This reveals different Temperature and Tint settings.

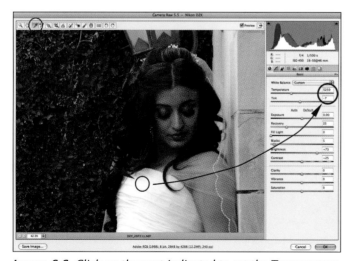

Image 6-6. Click on the spot indicated to set the Temperature and Tint.

Now that we are happy with the whiteness of the dress and the skin tone of the left image, we will use it as a reference for adjusting the other two images.

In the Layers palette, double click on the thumbnail of the "center" layer to bring up its Camera Raw dialog box. Because this image is cropped to be quite narrow, zoom in

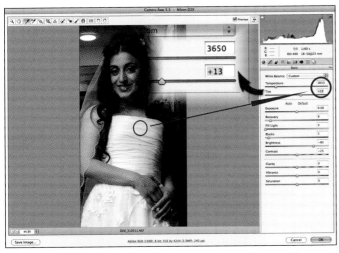

Image 6-8. Use the White Balance tool to click on the spot indicated to set the Temperature and Tint.

Image 6-10. Set the Color Picker for the Adjustment Brush as seen here.

to the upper half—but keep all her skin area visible. Now, pick up the White Balance tool and click on the dress, somewhere on the torso. I got Temperature 3650K and Tint +13 (**image 6-8**).

The 3650K reading indicates a much lower color temperature than the 5250K of the left image (the center image was lit by light bulbs in a wine cellar; the image on the left was lit by the sun). Now, look at her skin tone. It, too, looks rather bluish. The attempt to make the dress white has overcorrected the skin tone.

Let's pick up the Adjustment Brush (**image 6-9**). Click on the box to the right of Color to bring up the Color Picker dialog box. Set it as seen in **image 6-10**. We are using pure yellow at a Saturation setting of 20 to cancel out some of the excessive blueness on the skin. Set the brush to about the width of the bride's face and with some feathering, as indicated in **image 6-11**, then click and hold to apply a stroke down the face as indicated with the arrow. Reduce the brush size to about the width of her arm, then apply a second stroke down her right arm, to her hands, then up her left arm (until it disappears from view).

It is not a bad idea to move around the Camera Raw dialog box so you can see the Preview and the left image in our collage side by side—as in **image 6-12**. If you do so, you will find that the left image is still more yellowish. Click on the box next to Color again and bring up the Color Picker. To me, the setting indicated in **image 6-12** best matches the skin tone in the left image. Set it accordingly and click

Image 6-9. The Adjustment Brush tool.

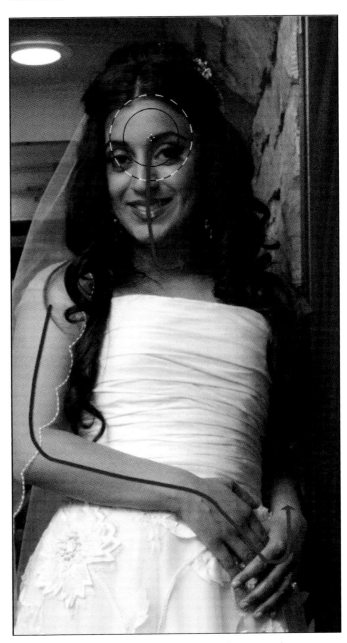

Image 6-11. Apply the Adjustment Brush as seen here.

Image 6-12. Move the Camera Raw dialog box around so the two images can be compared. Set the Color Picker as seen here so the skin tones are consistent.

Image 6-13. When setting the Color Picker for the Adjustment Brush on the "right" layer, these settings would work.

on OK to dismiss the Color Picker. Then click on OK in Camera Raw to go back to Photoshop.

Now, apply the same procedure to the "right" layer. After using the White Balance tool to turn the dress pure white, pick the Adjustment Brush. In the Color Picker, I found settings of Hue 53 and Saturation 59 best matched the skin tone, as indicated in **image 6-13**.

The final result will be like **image 6-14**. I am quite satisfied with how the color of the dress and skin match each other.

Here's a challenge for you. If you know how to make color adjustments in Photoshop using Levels or Curves

Image 6-14. Now the skin tones and dress color are very consistent.

(either in the RGB or LAB color spaces), go back to the original image ("skintones.psd"), rasterize the three Smart Objects to regular layers, then apply your color adjustments. I will proclaim you a master of color adjustment if you can come close to the result achieved using our Camera Raw approach.

NOISE: THE SOUND OF SILENCE

Noise remains a frontier in digital-imaging technology. While image sensors have vastly improved over the last decade, there is still an ample amount of noise lurking in the shadows. (The double meaning is intended here; noise is most prominent in the shadows.) Look at **image 6-15**, a shot of a color chart with my wife's seashell collection. This was photographed using an Olympus E3 camera at ISO 3200. As you can see, the noise is more noticeable in the darker areas. This image is very zoomed-in for you to see the noise. (More information on testing RAW images from different camera models appears in appendix B.)

A little background knowledge about how the noise is formed might help you to avoid—or fix—the problem. The

image sensor is basically a device that transforms photons to electrons. More photons hitting the sensor produces more electrons. The imaging process on the digital camera, therefore, starts with the business of counting electrons. When a high electron count is attributed to a certain pixel, a high gray level is assigned, making it a bright pixel. When a low electron count is attributed to a certain pixel, a low gray level is assigned, making it a dark pixel.

The problem arises when electrons go rogue. (One of the rogue electrons might even write a best-selling memoir of its experience. Check out 2009's current affairs if you don't get this joke.) These rogue electrons are produced by the sensor even when there are no photons hitting it, creating random brightness that does not actually exist.

As you might imagine, there are just a few rogue electrons. So at bright pixels where many "real" electrons are being produced, we do not feel the impact of a few rogues. However, when the gray level is low—at dark pixels—the influence of the rogue electrons increases. This is the reason why a digital photographer has to be particularly careful in handling the shadows if image quality is a high priority.

Another noise-related factor is the ISO setting. When the ISO has a low number (like 100), the sensitivity is low and it takes more electrons to be considered bright. When the ISO has big numbers (like 3200), the camera increases the sensitivity of the sensor, not by any hardware adjustment but simply by assigning a smaller electron count to the same gray level. Let's imagine 10,000 electrons are needed for a

Image 6-15. A shot of color charts made with an Olympus E3 camera at ISO 3200. Notice the noise in the darker areas.

pixel to be considered pure white when the ISO is 100. At ISO 3200, where the sensitivity is five stops higher, $^1/_{32}$ the amount of electrons will now be needed to be considered pure white. That's only 313 (10,000÷32) electrons! This means a few rogue electrons will have more influence.

Image 6-16. Our sample image for the noise exercise.

Image 6-17. In Camera Raw, zoom in to 200 percent and you'll see noise in the background (here with partial magnification).

QUIET DOWN! KILL THAT NOISE!

Unlike the grains on film, which create a sort of pleasant, organic look, digital noise is hardly appreciated. We will have to try to eliminate it.

EXERCISE: CLEAN UP THE BACKGROUND

1. From the downloaded companion files, find "karate. dng" and open it into Camera Raw.

2. Work along with the following discussions.

Our subject here has been working on her karate for years—and the red belt you see in **image 6-16** will soon be replaced by a black one. While her white robe stands out quite dramatically in front of the charcoal background paper, this kind of dark gray can result in a noise problem. In **image 6-17**, you see this image opened into Camera Raw; I zoomed in to 200 percent to the area of the subject's right shoulder. Check out the background. Meet the notorious noise, presented here as random specks of gray that are slightly brighter or darker than the surrounding tones.

This image was shot on a Nikon D2X camera at its lowest ISO setting (100). That means the lowest noise level on this camera still can't avoid what you are looking at. The D2X was about five years old when this book was written.

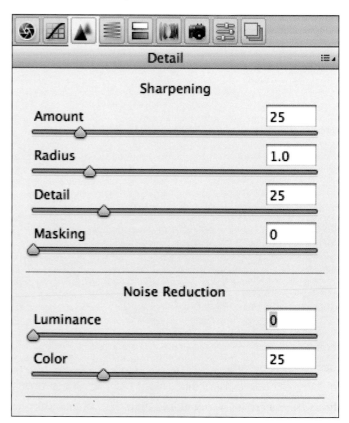

Image 6-18. The Detail tab in Camera Raw.

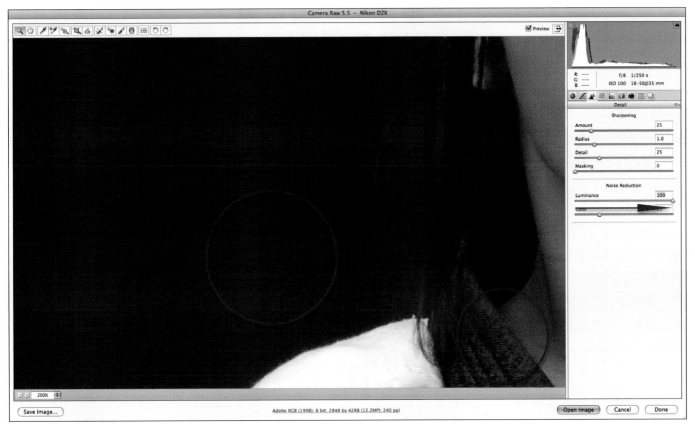

Image 6-19. Move the Luminance slider all the way to the right and watch the noise disappear in the circled areas.

Some more recent models are vastly improved in the noise department—but only some, not all. You'll find more on this topic in appendix B.

In Camera Raw, the Noise Reduction settings are located under the Detail tab. This is indicated by a sharp triangle and a fuzzy triangle. (Sometimes you just have to admire how the Photoshop team at Adobe comes up with meaningful symbols.) Click on this tab and you will see the contents of the panel, as in **image 6-18**. We will focus on the lower half of the tab, which deals with noise.

There are two sliders here: Luminance and Color. These target two different kinds of noise. But what type of noise do we have here? Try the sliders to find out. When you increase each slider (one at a time) to the highest setting, you'll see that Luminance makes a great difference; Color does nothing at all. That answers our question.

Look at **image 6-19**. Here, the Luminance is set to 100 and noise in the background has mostly vanished. Hooray! Is the mission accomplished, though? Let's not start celebrating quite yet. Look at the collar, hair, and skin. They turned fuzzy. If you are following along, drag the Luminance slider back and forth between 0 and 100. Uh-oh. The Luminance

treatment appears to be very invasive. Like many medicines, it cures one symptom and causes another two. In the end, we don't even know if it is the sickness or the side effect that kills the patient. The side effect of Noise Reduction is a loss of sharpness . . . which is almost as bad as the noise itself.

I said that knowing the mechanism behind the creation of noise might help us getting rid of it. Since the noise's prominence is in opposite proportion to brightness, why don't we apply the strong noise reduction only to darker areas? Doing this will avoid making the details fuzzy. Using our medical analogy, this will be like targeting the medicine at certain organs to reduce the global side effects. Finally we have a plan for our patient's survival!

First, let's open "karate.dng" into a Smart Object. You might have noticed that the Basic tab has some custom settings I have applied. Keep those. Also, keep the Noise Reduction setting at its default. Press and hold Shift, then click on Open Object.

Now the image is in Photoshop. Press Z to activate the Zoom tool, then click on the right shoulder area six times to get to a 200 percent view. Here is the plan. We will create a Smart Object layer that contains the minimized noise. We

will place this layer on top of the Smart Object, which is set to no noise reduction. Then we will use a layer mask on the low-noise layer so only its dark area shows. We will then look at an image that has all the sharpness in the highlights and midtones and no noise in the shadows. Sound good to you?

Go to Layers palette and double click on the thumbnail of the only layer. Since this is a Camera Raw Smart Object, the Camera Raw dialog box opens up. Go to the Detail tab and set the Luminance all the way up to 100, as we did in **image 6-19**. Click OK to accept the change.

You can see, in our 200 percent view, that the noise is gone. Now we will need to duplicate the "karate" layer. Do this by dragging it to the Create a New Layer button at the bottom of the Layers palette. Now you have a new layer called "karate copy." A quick-thinking reader might think, "A-ha! Now we will set the two Smart Objects differently and apply the mask." Not so fast. There is a slight glitch— and I will show it to you by wandering down this wrong road.

Double click the thumbnail of "karate copy." In the Camera Raw dialog box, go the Saturation slider and reduce it all the way to the left. The Preview image turns black & white. Click on OK to accept the change. Now look at the Layers palette. The thumbnail of "karate copy" turned black & white—but so did the original "karate" layer! The lesson is this: If a Smart Object is duplicated onto two layers, it is still the same Smart Object; you can't adjust the two independently.

If you followed me down this wrong road, go to the History palette and backtrack three steps to where we increased the noise reduction. This also undoes the layer duplication.

Open "karate.dng" again. In Camera Raw, go to the Detail tab and you will find the Luminance set to 100. This because the previous settings have been recorded and are applied to all subsequent openings. Decrease the Luminance to 0. Press and hold Shift, then click on Open Object. The image now is opened for a second time with a name "karate as Smart Object–2".

Now you have two identical images opened in Photoshop. Press V to activate the Move tool, then click and drag the image in "karate as Smart Object–1" into the image "karate as Smart Object–2". Do not let go the click yet; press and hold Shift, then release the click. Holding Shift forces the layer we are dragging in to be aligned perfectly with the original.

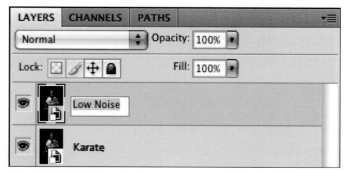

Image 6-20. Giving the layer a meaningful name.

Direct your attention to the Layers palette and you will see now see two layers. Both are Smart Objects with the same name: "karate". They are, in fact, two separate Smart Objects and can be adjusted independently. Double click on the name of the top layer and rename it "Low Noise", as indicated in **image 6-20**.

What we need now is a Layer Mask for the "Low Noise" layer. This mask will hide all the highlights and midtones, revealing only the shadow areas. What would be the best tool to create a mask like this?

I suggest using Threshold—a not-so-often-used kind of adjustment layer. If your image is still zoomed in to the subject's shoulder, press Z to activate the Zoom tool, then right click on the image (or on a Mac with no right click button, Alt+click) and choose Fit on Screen from the menu that pops up. In the Layers palette, make sure the "Low Noise" layer is active, then click on the Create New Fill or Adjustment Layer button and choose Threshold. You will see your image turn to black and white—and I do mean *only* black and *only* white; there is no gray. Look at the Adjustments palette (or dialog box, if you are working with CS3 or earlier). The little triangle under the histogram decides the Threshold's gray level, which is by default 128. This means any pixel in the original that is brighter than 128 becomes white and any pixel that is darker than 128 becomes black. This is illustrated in **image 6-21**.

White in a mask means "show" and black means "hide." Therefore, the effect that Threshold produced happens to be the inverse of what we need. So let's add another adjustment layer—an Invert layer. Go the bottom of Layers palette, click on Create New Fill or Adjustment Layer button and choose Invert. Now the image looks more like what we need for our mask, as indicated in **image 6-22**.

Click on the Threshold layer and activate its Adjustments palette (or double click it to bring up its dialog box, for CS3

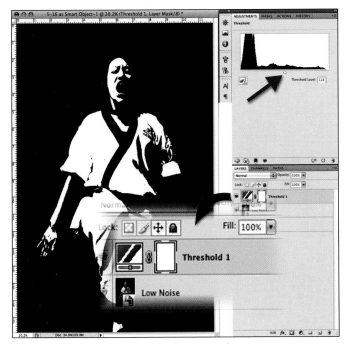

Image 6-21. The Threshold adjustment layer.

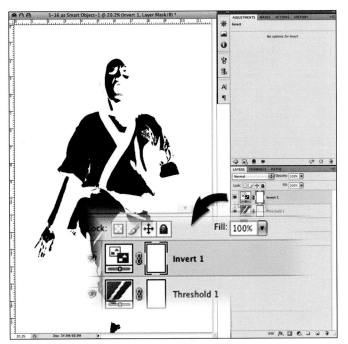

Image 6-22. The Invert adjustment layer.

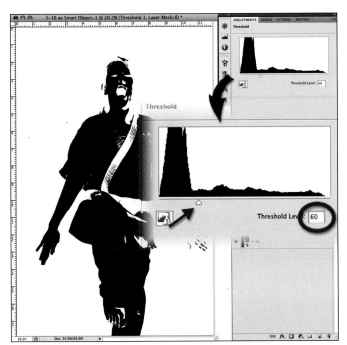

Image 6-23. Adjusting the Threshold layer.

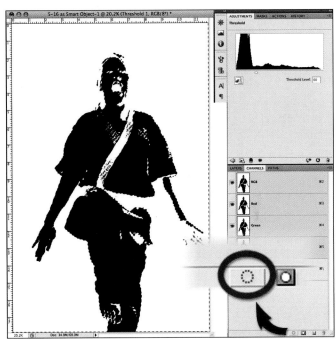

Image 6-24. Creating a selection in the Channels palette.

and earlier). We will now shift the Threshold triangle around while looking at the image so we can decide what Threshold setting is the best. We want the whole background to be white and we want as little white as possible on the subject and her clothing. A little bit of white on the dark areas around her belt, hair, and skin will be fine; some noise might need to be killed there, anyway. I have concluded that setting the Threshold at 60 would be the best, as indicated in **image 6-23**.

Now, we need to convert this image into a mask. To do that, we first create a selection out of this image. Click on the Channels palette to activate it. Then, click on any of the channels. (It does not matter which one; they are all the same under our current black & white image.) At the bottom of the Channels palette, click on the Load Channel as Selection button (with the dotted circle). Now we have marching ants on the image, indicating an active selection (**image 6-24**).

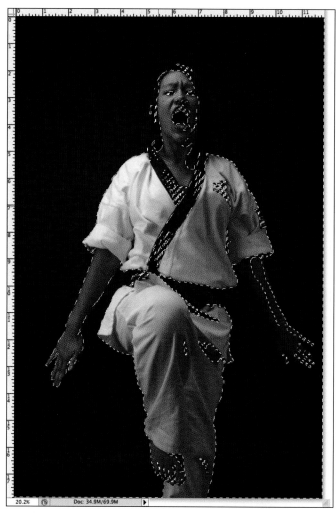

Image 6-25. The selection on top of the "Low Noise" layer.

Image 6-26. The selection has been converted to a mask for the "Low Noise" layer.

Click on the Layers tab to activate it. The Threshold and Invert layers have served their purpose, so we can turn off their visibility by clicking on the Layer Visibility icons (the eyeball icons). Being a big proponent of nondestructive procedures, I do not choose to discard them. Now, the selection is directly above the image, as in **image 6-25**.

In the Layers palette, click on the "Low Noise" layer to activate it. Go to the bottom of the Layers palette and click on the Add Layer Mask button; the "Low Noise" layer gets a mask (**image 6-26**).

Our work is done! In **image 6-27**, there is a rather noise-free background and the sharpness on the robe and skin have been well preserved. If you are following along, you can do before/after comparisons. First, you may turn on/off the visibility of the "Low Noise" layer and see how the noise in the background differs. Then you can right click (or on a Mac with no right click button, Alt+click) on the layer

Image 6-27. A nearly noise-free image, thanks to the robust Camera Raw.

mask of the "Low Noise" layer and disable/enable it to see how the details are preserved.

Now we can declare our mission accomplished! We could also have accomplished the mission if the order of the two

layers had been reversed. The mask then would then be on the "high noise" layer and the Invert adjustment layer would not have been required. In Photoshop, there are always different ways to achieve the same outcome.

MORE THEORIES ABOUT NOISE

When it comes to Photoshop skills, I am a believer in hands-on experience. From hands-on experience one cultivates practical knowledge that is usable in real-life situations. Another approach is to gain knowledge by studying how and why things work. The insight we gain from this approach can often lead to innovative techniques.

By studying how noise is formed, it dawned on me how noise can be minimized by manipulating the camera settings. Combining these manipulations with the power of Camera Raw and other functions in Photoshop, it is possible to produce nearly noise-free images. Let me place a light bulb on top of your head by showing you the theory—then, in a few pages, I will flip the switch to turn it on at the eureka moment. Please hold your applause until then!

A few pages earlier I was explaining how noise is produced by rogue electrons. Why don't we look at the noise phenomenon in terms of a histogram?

Image 6-28 is the same histogram we used as introduction earlier in this book. The only difference is that I added an illustration of where the noise lurks. This is based on our knowledge that the rogue electrons cause slight variations of brightness that are normally more visible in the shadow. In this illustration, a red area is marked as the range of noise. When we view the very dark area of the image, it gets very noisy. (I want to make it clear that by no means is there noise only at this part of the histogram—but when we get into the midtones and highlights, the noise becomes essentially invisible, so we will ignore those areas in this discussion.)

Let's say the image was correctly exposed with a shutter speed of $^1/_{1000}$ second and an aperture of f/5.6. If the same scene was shot at $^1/_{1000}$ second with an aperture setting of f/2.8, it would be overexposed by two stops. When an image is overexposed, something that appeared black becomes gray. Consequently, the histogram of the overexposed image would be a stretched version of the one for the correctly exposed image. As illustrated in **image 6-29**, the peak that was darker than the midtone is now pushed beyond the midtone point.

However, since the ISO setting did not change, the rogue electrons did not gain any territory. Therefore, the

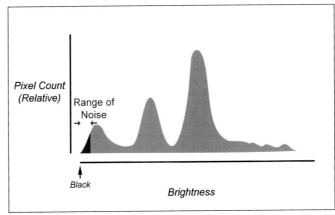

Image 6-28. Noise is lurking in the darkest part of the histogram.

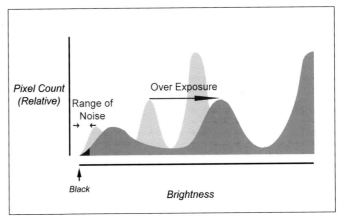

Image 6-29. If the image is overexposed, the range of noise remains the same.

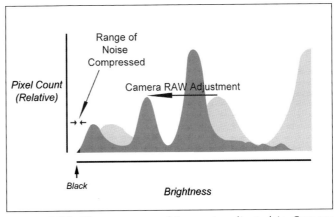

Image 6-30. The overexposed image is adjusted in Camera Raw and the noise's range is compressed.

red area stays the same. It is not extended to the right. (Are you getting excited about what's coming?) This means that we can open this overexposed image and do something we have done before: Adjust the Exposure slider to reclaim the highlights. In this case, since we overexposed by two stops, we would adjust the Exposure slider to –2. As illustrated in **image 6-30**, the peak is pushed back to where it belongs. And

Image 6-31. Zoom in on "shells1.dng" to see the horrendous noise.

Image 6-32. The image "shells2.dng" was overexposed by two stops.

guess what happens to the range of noise? It is compressed! This means the noise is decreased!

My dear readers, if you are not throwing the book in the air and doing ten somersaults, you are just not my type. (Okay, leave the somersaults out—I don't want anyone to get hurt.) Let's put this theory to the test.

EXERCISE: COMPRESS THE NOISE

1. From the downloaded companion files, find "shells1. dng" and "shells2.dng" and open them into Camera Raw.
2. Work along with the following discussions.

In **image 6-31** you can see two images of a color chart and my wife's shell collection opened in Camera Raw. The Preview shows the lower right corner of "shells1.dng" zoomed in to 100 percent. While this image was made at the correct exposure, our second image ("shells2.dng", seen in **image 6-32)** is two stops overexposed. These shots were made on a Nikon D700 on its whopping ISO 6400 setting. The image quality is the state-of-the-art, but the noise level is still rather prominent once we scrutinize the shadow, as you can see in the Preview panel of **image 6-31**.

Click on the thumbnail of the overexposed image ("shells2.dng") to load it into the Preview panel. What you see will be like **image 6-32**. The overexposure is evident

in both the Preview and the histogram. Our task will be to adjust the overexposed image so it looks as similar as possible to the correctly exposed one. I found that setting the Exposure slider at –2.00 and the Brightness slider at +75 was satisfactory, making the two images look quite similar, as you can see in **image 6-33**.

Now, go to the lower left corner of the Preview and set the zoom to 100 percent. Press and hold the Space bar to get the Pan tool and pan the image to the same area we examined in **image 6-31**. What you will see is like **image 6-34**. The noise level is much lower, so my theory is proven correct!

WHEN IT'S TOO BRIGHT, SQUINT

As we learned in chapter 4, RAW images actually keep data that is brighter than white. This means highlight details lost to clipping can be restored. This is good for us, since the range of adjustment is greatly improved. However, among all the cameras I have tested, the recordable range beyond white is hardly more than 1.5 stops. In other words, if the level of overexposure goes beyond 1.5 stops, even RAW might not save it.

We will explore a technique to fix this problem. The principle is quite similar to what all of us do when we try to look at something that is too bright: We squint.

Image 6-33. The overexposed image was adjusted in Camera Raw to closely match the correctly exposed image.

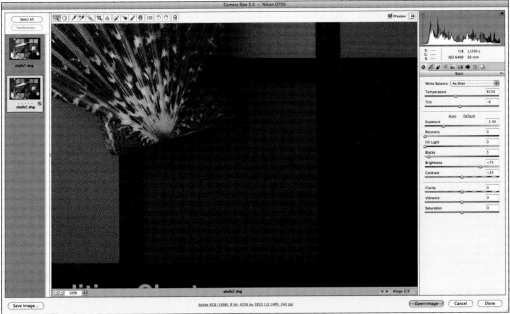

Image 6-34. Zooming in, you will find very little noise in the initially overexposed image that has now been restored to a correct exposure level in Camera Raw.

EXERCISE: SQUINTING

1. From the downloaded companion files, find "mountain1.dng" and "mountain2.dng" and open them into Camera Raw.

2. Work along with the following discussions.

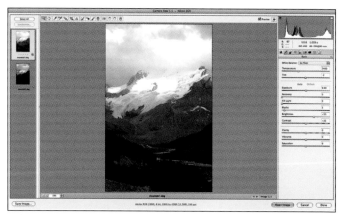

Image 6-35. The images for this exercise are opened into Camera Raw. The file "mountain1.dng" is visible in the Preview panel.

Image 6-36. Highlight clipping is evident.

Image 6-37. Highlight clipping stubbornly stays with use even at –3.00 on the Exposure slider.

Look at **image 6-35**. This is another shot of the Canadian Rocky Mountains at Banff. There is a glacier in the background and a river valley in the foreground. The exposure was set to the average of the bright background and dark foreground, producing some hot spots on the glacier. Zoom in to that area, as indicated in **image 6-36**. In the Histogram, you can also see the clipping at the highlight end. Can we pull the same trick as we did in chapter 4 to get rid of the hot spot and recover the details? Let's try.

The plan is to set the Exposure lower to recover the details on the glacier. If that works, we will of course have a very dark image. We will then try to push the brightness back up by increasing the Brightness slider.

Unfortunately, dragging the Exposure slider down to –3.00 produces a Preview like **image 6-37**. The hot spot is still alive and well. It seems that the hot spot on the glacier is too hot for Camera RAW to cool down.

Our other image for this exercise ("mountain2.dng"), on the other hand, was shot with ½–1 stop of exposure compensation. Look at **image 6-38**. The river valley looks

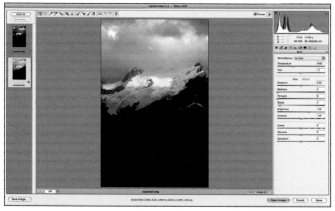

Image 6-38. This image of the same scene was underexposed by 1 stop.

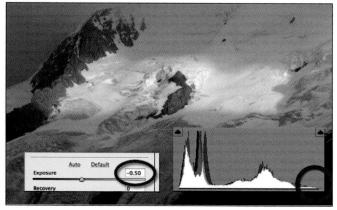

Image 6-39. A –0.50 Exposure adjustment fully recovers all the details on the glacier.

Image 6-40. After the adjustment, the "mountain2.dng" image is too dark.

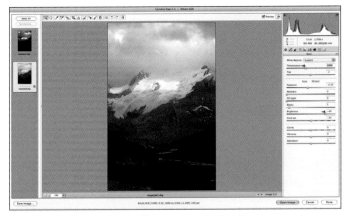

Image 6-41. Further adjustment of the image produces a better result (Temperature 5900, Brightness +90).

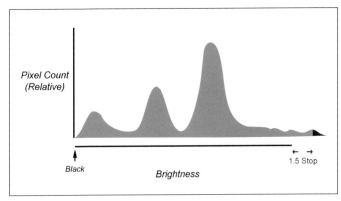

Image 6-42. Camera Raw can't recover the red area on the histogram, as indicated here

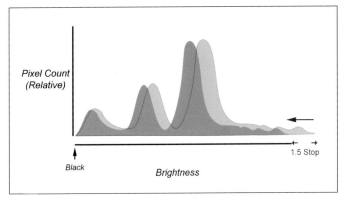

Image 6-43. Slightly reducing the exposure when shooting, then further reducing the Exposure in Camera Raw, can fully preserve the highlight details.

very underexposed, so of course this has to be adjusted eventually. But before we spend time doing that, though, we should check the hot spot issue on this shot.

Zooming in to the glacier and reducing the Exposure slider to –0.50 produces a Preview like **image 6-39**. The details on the glacier are much better preserved here. It makes me want to ski there—but, while I am an adventurist in the world of Photoshop, I am not a fan of sports that might compromise my limbs. So I will leave that excitement to someone more keen on breaking their legs.

Now, with the Zoom tool activated, right click (or on a Mac with no right click button, Alt+click) on the Preview and choose Fit in View. As you can see in **image 6-40**, the image is way too dark overall. If you set the Brightness slider to +90, the image looks a lot brighter and the highlights on the glacier are still not blown out. Pull the Temperature

slider to 5900K to take out the blue hue on the hills, as seen in **image 6-41**.

So underexposing an image produced a better shot. This is just like squinting your eyes when it is too bright; the half-closed eyelids reduce the light so our visual nerves can take it.

This technique can also be illustrated with histograms. **Image 6-42** shows a histogram of an image with overexposure beyond 1.5 stop. The red shaded area cannot be regained, even after reducing the Exposure setting.

Image 6-43 shows the histogram of the same image with underexposure. The highlight is still clipped, but it's less than 1.5 stop out of range. This is a hot spot that can be cooled. In Camera Raw, we first recover the clipped highlight by reducing the Exposure slider, then we can regain the brightness by increasing the setting of the Brightness slider.

Can we put the noise-compression and eye-squinting techniques together for practical purposes? You bet. I have the perfect images to demonstrate this in the following section.

Image 6-44. An Old Faithful Lodge shoot-out between this camerawoman and me.

A BREEDING GROUND FOR NOISE

Yellowstone is a magical place. On top of all the natural wonders, there is also the Old Faithful Lodge, an architectural gem. The lobby inside the lodge features a 73-foot high vaulted wooden ceiling. The tranquility of the lobby has a lot to do with the dark brown logs and the dim light trickling in through the small windows. Mesmerizing as it is, it poses a great challenge for photographers: low light and dark colors are breeding grounds for noise.

While I was pondering a technique I could use to achieve a high-quality image, another professional photographer was using the approach of artificial lighting, as seen in **image 6-44**. While she was triggering half a dozen strobe heads, I was thinking about Camera Raw and Photoshop. I only learned afterward that I happened to be an unwanted subject in her shots. I am sure she didn't mind—assuming she knew how to remove me in Photoshop. (But if you happen to be reading this book, dear stranger/photographer, sorry to be in your shots.)

EXERCISE: NOISE-FREE OLD FAITHFUL LODGE

1. From the downloaded companion files, find "lodge1. dng" and "lodge2.dng" and open them into Camera Raw.
2. Work along with the following discussions.

In **images 6-45** and **6-46**, our files are opened in Camera Raw. These shots were made with the bracketing setting on the camera, producing multiple shots with exposure compensations at varying levels. I set the camera to capture seven images with half a stop difference in exposure compensation between each frame. Then I leaned the camera on a rail, set the shooting mode to high "rapid fire" mode, and shot away. These are two of the seven bracketed shots. Respectively, they are about 1.5 stops underexposed and 2.5 stops overexposed (or at least that was how the camera was set to meter; the actual outcomes do not precisely reflect such settings due to metering imprecision).

First, we are going to adjust both images so they look identically and correctly exposed. Their colors are a bit off, too, so some adjustments using the Temperature and Tint sliders are in order. After some effort, I found that the settings indicated in **images 6-47** and **6-48** sufficed. With these settings in place, click the Select All button at the top of the thumbnails to select both images. Then click Open Images (yes, Camera Raw changed it to the plural—how thoughtful!) to open the files into Photoshop.

When you have both images open, tile them side by side. Use the Move tool to drag "lodge1" into "lodge2." Be sure to press and hold Shift to force alignment on the incoming layer. In this case, unfortunately, aligned layers do not guarantee aligned images—after all, these are two different

Image 6-45. The "lodge1.dng" file opened in Camera Raw.

Image 6-46. The "lodge2.dng" file opened in Camera Raw.

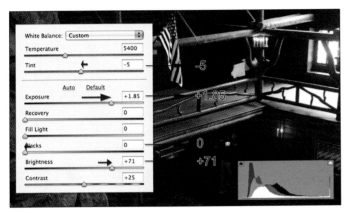

Image 6-47. Adjustment for the underexposed image.

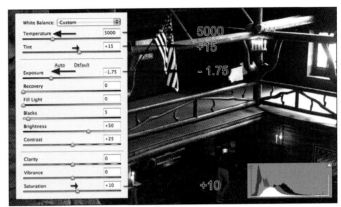

Image 6-48. The adjustment for the overexposed image.

shots. Remember, I was not using a tripod. Although I did rest the camera on the rail, there was still plenty of chance for movement between the shots. Also, these two shots were not made back-to-back; there were other bracketed shots in between them.

One easy way to verify the alignment is to quickly turn on and off the visibility of the top layer and see if the image "wobbles." My test here, unfortunately, shows a slight shift between the two. Another way to verify is to turn the opacity of the top layer down to 50 percent and zoom in to a detail. As illustrated in **image 6-49**, the two shots clearly do not align. (There goes my career as a sharp shooter!)

Should we try to manually align the images? I would strongly recommend against it. Our goal here is a high-quality image, and even a single pixel out of alignment would seriously compromise that. It would be like me watching an HD television with my glasses off; the benefit would be seriously compromised.

What should we do? Let me show you a totally unorthodox use of the fancy Photomerge feature in Photoshop. Photomerge is conventionally used as a tool to "stitch" multiple images together to form panoramic images with high pixel

Image 6-49. There is a slight displacement between the two images.

counts. In our case, however, we will exploit its amazing ability to align images.

Close the files you currently have open. This is a must, or Photomerge might use the misaligned layers in our previous attempt as the source. Go to File>Automate>Photomerge to bring up the dialog box, then click on Browse to locate "lodge1.dng" and "lodge2.dng" and bring them into the Source File box, as indicated in **image 6-50**. Keep all the default settings and click OK to start the process. Now you can sit back, relax, and watch the show.

While Photoshop is working, there are a couple things that you should know. First, the adjustments we applied to both images were recorded in the the files by Camera Raw,

Image 6-50. *The Photomerge dialog box*

Image 6-51. *The Photomerge dialog box*

Images 6-52 and 6-53. *Comparing one area of the two layers. The left is "lodge1" and the right is "lodge2".*

Images 6-54 and 6-55. *Comparing one area of the two layers. The left is "lodge1" and the right is "lodge2".*

so Photomerge will work with the adjusted images. This is how we want it. Second is Photomerge's algorithm involves random sampling. (How else would you imagine your computer compares millions of pixels, recognizes and matches patterns, then resamples the images to align then—all in a matter of minutes?) This means the result of Photomerge is different every single time. I have a Photomerge demo that I have presented to students across the nation more than a hundred times—and every demo resulted in a different final image. There was even one time—and only once—that Photomerge totally failed. Fascinating, right?

When my attempted Photomerge is finished here, the Layers palette of the newly created image, called "Untitled Panorama2" ("2" because I had done another Photomerge earlier in this Photoshop session), looks like **image 6-51.** What we have here is layer made of "lodge1" on top of layer "lodge2". The mask of the "lodge1" layer is totally black because Photoshop found no need to use any part of the layer to create the stitched image. If you were creating a panorama, you would see the masks skillfully painted so each layer contributed parts of the finished image.

We will now discard the mask of "lodge1" by dragging it into the Trash at the bottom of the Layers palette. Discard only the mask, not the layer. When Photoshop asks "Apply mask to layer before removing?", answer by hitting Delete. Now that the pure black mask is gone, we are looking at "lodge1" as the top layer. Try turning the layer's visibility on and off to check the alignment. You should find that Photomerge has done an excellent job. Now the only things

that "wobble" in the alignment are the people behind the counter. We can fix that later.

Let's compare the pros and cons of these two layers. Zoom in to 200 percent to the left side of the flag. By turning the visibility of "lodge1" on and off, we can see this area in "lodge1" and "lodge2." This is shown in **images 6-52** and **6-53**, respectively. You can clearly see that "lodge2" has much finer details and much less noise. Even the nails on the wooden panels are discernible. The overexposure technique worked once again by dramatically improving the quality in the shadow and midtone areas.

Now let's zoom out to 100 percent and pan to the right of the image where there are a window and candles. **Image 6-54** shows "lodge1" and **image 6-55** shows "lodge2". It is a no-brainer for us to choose "lodge1" for the highlight. In "lodge2", the highlights are burned out, creating hot spots that can't be recovered. Remember that we are only using highlights from "lodge1", so the noisy wooden panels between the window and the candles are not going to show.

So our vote is "lodge1" for the highlights and "lodge2" for the midtones and shadows. It's time to summon the Threshold function again. Click on the Create New Fill or Adjustment Layer button at the bottom of the Layers palette, then choose Threshold. I found the default setting, illustrated in **image 6-56**, provided an ideal mask. The highlights of the candle, window, and well-lit logs are white. This, in turn, will be the white area on the mask.

Click on the tab of the Channels palette. Click on any of the channels, then go to the bottom and click on the

Image 6-56.
Using a Threshold
adjustment layer
and setting the
threshold.

Image 6-57. Creating a selection in the Channels palette.

Image 6-58. In the Layers palette, turn off the Threshold adjustment layer.

Image 6-59. Apply Refine Edge to the selection and observe the preview.

Image 6-60. The selection after the Refine Edge process is applied.

Load Channel as Selection button. A selection will be loaded according to the black & white image, as illustrated in **image 6-57.**

Go back to the Layers palette and turn off the visibility of the "Threshold 1" adjustment layer by clicking on the Layer Visibility (eyeball) icon. Now the selection is right above the "lodge1" layer, as illustrated in image **image 6-58.**

There is one more thing to do before we create the mask. The current selection is very hard-edged, because there was no gray in the Threshold image. This will cause visible artifacting, because our two layers are not identical. We will need more gradual transitions between "showing" and "not showing."

With the selection still active, go to Select>Refine Edge. This will help us cut off of the selection more gradually. I found that setting Feather to 30 pixels and Contract/Expand to +70 was best for picking up the highlights we want. See **image 6-59**, which shows exactly how the "lodge1" layer will look once the mask is applied. I actually quite like the look of this image. It looks dreamy. Now, stop daydreaming and click on OK to accept the refined edge.

As you can see in **image 6-60**, the marching ants now mark the average of the graduated selection. In the Layers palette, make sure "lodge1" is activated, then go to the bottom and click on the Add Layer Mask button. Now, a very complicated mask is applied to our "lodge1" layer.

Don't forget the front desk clerk, who was busy doing something between the two shots, as indicated in **image 6-61**. What we need to do here is to allow her face to be displayed by just one layer—not partially by each layer. To

Image 6-61. Movement of the clerk.

Image 6-62. Brush black on the "lodge1" layer mask to hide her head on this layer so she is only showing on the "lodge2" layer.

Images 6-63 and 6-64. Spots that need some fine-tuning on the mask.

do this, press B to choose the Brush tool. Adjust the brush hardness to 0 and the size to slightly bigger than her head. In the Layers palette, click on the mask of "lodge1" to activate it, then make sure the foreground color (indicated at the bottom of the tool bar) is set to black. Brush on her head, as indicated in **image 6-62**. The ghostly image is now clearly defined.

Before we proclaim our mission accomplished, we should zoom in and examine the details. By doing so you might find a few spots where the masking of "lodge1" was not perfect—as you can see in **images 6-63** and **6-64**. To fix this, activate the mask on the "lodge2" layer and use the Brush tool to paint black or white (to hide or show) the "lodge1" layer.

Image 6-65. The "perfect" image after the procedures. Circled areas highlight the obvious improvement.

If you are following along, you might come to the conclusion that I should have used less Expand in the Refine Edge step. You are right. However, I wanted to show you the retouching with the Brush tool here as an alternative to redoing a previous step. The ability to touch things up with the Brush tool on a mask is part of the beauty of the nondestructive procedure enabled by layers and layer masks.

After the final touch-up, the result is **image 6-65**, in which the details in both shadows and highlights are well preserved and the noise is at a minimal level. Hooray!

A CONTINUING ANALOGY

At the beginning of this book, I illustrated the benefit of shooting RAW (rather than JPG) with the analogy of Mark Chen as a "so-so" tennis player with a normal racket. If shooting RAW is like increasing the size of the sweet spot of a racket, using the above technique is like using a double-headed racket—as illustrated in **image 6-66**. With the large sweet spot now doubled, even I could keep my eyes closed and volley back Roger Federer's blazing ground stroke!

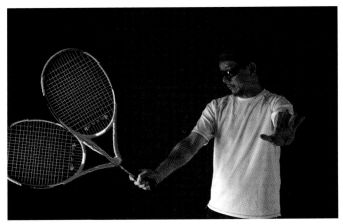

Image 6-66. Mark Chen the tennis player using a double-headed tennis racket.

QUIZ 4 — SANITIZING THE SANITIZER SHOT

Find file "sanitizer.dng" among the companion files and open it into Camera Raw. You will see an image of a pair of hands applying hand sanitizer, as in **image 6-67**. There are a couple technical flaws and challenges here. First, the lower part of the background is a little too shadowy. This was caused by the silhouette lighting, in which frontal lighting is minimal. Second, the main focus (the hands) are the darkest objects here. Therefore, noise becomes a concern, as indicated in **image 6-68**. Your assignment is to fix/improve these two problems. Give it a try on your own, then turn to appendix D to see how I did it.

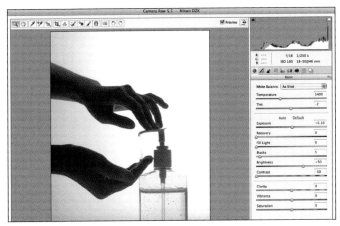

Image 6-67. The original hand-sanitizer shot.

Image 6-68. Noise is a concern in this image.

APPENDIX A

Camera Raw and Bridge

Bridge is an organizational tool that aims to make our lives easier. Unfortunately, since its introduction with Photoshop CS2, a few setbacks in the process of achieving that goal did leave a bad taste in some users' mouths. In the hundreds of Photoshop classes I have taught, only about 30 percent of students were using Bridge.

The good news is that the setbacks are a thing of the past. At the time of this writing, Bridge CS4 has proven itself a versatile tool with robust performance. You shouldn't have doubts about using Bridge—as long as you are aware of certain important limitations:

1. Like Photoshop, the performance of Bridge depends heavily on the performance of the computer. Bridge needs to access memory and hard drives constantly, so a computer with ample RAM and fast hard drives can provide a much happier Bridge experience.

2. In a local area network (LAN) environment (*e.g.*, your home wireless network or the corporate network), I strongly caution against browsing through a folder on a remote drive with a large number of RAW files. Attempting to do so will result in very poor performance. Thumbnails take forever to load, and scrolling up and down through the files becomes as suspenseful (and scary) as any Hitchcock movie. The bandwidth of a LAN is still no match for that of a local drive. Therefore, the best practice is to move those large folders to local drives. When the work is done they can be loaded back to the server or a remote computer. (Your IT people don't like this? Ask them to read this book and tell them I *was* an IT people—that is, before I found the true meaning of life in Photoshop. The fact is, Photoshop poses some unique IT requirements.)

This chapter does not serve as an introduction to the usage of Bridge. The sole focus is exploring how it helps us in our Camera Raw endeavor. For a more complete introduction to Adobe Bridge, you will need another book. However, since Bridge is very self-explanatory, many of you might find it suffices just to explore on your own.

BRIDGE AS A MANAGER
TO CAMERA RAW ADJUSTMENTS
EXERCISE: BRIDGING THE RAW FILES

1. In the Folder panel of Bridge, navigate to the "Appendix Bridge Demo" folder in the companion files.
2. Work along through the following discussions.

Image A-1 is how Bridge looks on my Mac. Like Photoshop, the Bridge "workspace" can be customized to your liking. This workspace is the one and only "MARK" workspace. I arranged it this way simply because I like how it has all the things I need. You should make your own workspace—or if you want to use mine, feel free to do so. To shape your own workspace, drag the tabs around and resize the dividers between them.

Direct your attention to the thumbnails in the Content panel. Some of the thumbnails have a symbol of two sliders. This symbol denotes an image that has been "adjusted." All the thumbnails marked with these have been adjusted in Camera Raw and those adjustments have been recorded. Note that I did not use the word "saved." Truly, nothing is saved and nothing can be saved; RAW files are read-only. The proprietary RAW files can be only produced by the camera; DNGs are produced by the DNG converter or by Camera Raw (this topic will be covered in appendix C). In either case, once they are created, they can't be written over.

Image A-1. In the Folders panel, navigate to the "Appendix Bridge Demo" file. Shown here is a workspace customized to author's own liking and saved with a unique name.

One important detail here is that all my files have their extensions displayed under the Thumbnails. This is a vital setting that will make your work a lot easier. Keep in mind, however, that this setting is not controlled by Bridge. You will have to go into the Preferences in Windows Explorer (PC) or the Finder (Mac), to set this option.

Now, double click on "4-01.dng" and open it into Camera Raw. In the Basic tab, you can see some adjustment I made before loading this file to Amherst Media's website. These adjustments are recorded in the DNG file using a structure called XMP. Click Cancel to dismiss this Camera Raw dialog box.

Back in Bridge, right click (or on a Mac with no right click button, Alt+click) the thumbnail of "4-01.dng" and go Develop Settings>Clear Settings, as illustrated in **image A-2.** Immediately, the image looks darker in both the thumbnail and the preview—because the Exposure adjustment made in Camera Raw has been eliminated. The "adjusted" symbol also disappears. Our file is now back to its old self.

Next, double click on the file called "D2X_5609" to open it into Camera Raw. This shot of a tranquil autumn lake at Yellowstone National Park can be adjusted to improve the

Image A-2. Right click (or on a Mac with no right click button, Alt+click) to bring up this menu where the adjustment to a RAW image can be removed.

contrast and vibrance. I am not going to go into the details of these adjustments (that was demonstrated in chapter 4), but the following settings would do a great job: Exposure +1.10, Blacks 15, Brightness +28, and Vibrance +20. Set the adjustments as such and click Done. Back in Bridge, the thumbnail and preview of "D2X_5609" appear adjusted.

The file also has the "adjusted" symbol next to it (**image A-3**).

Look at "D2X_5610" to "D2X_5613". These four shots were made, together with "D2X_5609", to create a panorama. It would be a good idea to give all of these images a consistent look. Bridge can be great help when it comes to

Image A-3. After the image has been adjusted, the "adjusted" symbol appears at the top right corner of the thumbnail and the preview reflects the adjustments.

Image A-4. Right click (or on a Mac with no right click button, Alt+click) the selected thumbnails to get to the menu where an identical adjustment can be applied to many images.

Image A-5. Now the adjustment of "D2X_5609" has spread to the others. The adjustment is immediately noticeable on the thumbnails.

this. Click on "D2X_5610" then press and hold Shift to click on "D2X_5613" to select multiple files in sequence. Right click (or on a Mac with no right click button, Alt+click) on any of the selected files and go Develop Settings>Previous Conversion, as in **image A-4**. In a few seconds, all four images will reflect the same adjustments we made to "D2X_5609" (**image A-5**).

Now let's double click on "4-29.dng" to open it up. If you have read chapter 5, you will be familiar with the procedure for cropping this image in Camera Raw. If not, please refer to that chapter and perform the procedure. After it is completed and the Camera Raw dialog box dismissed by either clicking the Open Image or Done button, a look at Bridge will reveal the thumbnail seen in **image A-6**. Note that there is now a "cropped" symbol next to the "adjusted" symbol. Open the image again and it will be presented in the cropped form. Best of all, since nothing is actually written over the original RAW file, this can be undone quickly.

CAMERA RAW PREFERENCES

There are two important features that I need to point out about setting Camera Raw Preferences. In Bridge, these are located under the File (PC) or Adobe Bridge menu (Mac). Bring the Preferences up and you will see a dialog box like **image A-7**.

The very top pull down-menu is an important setting. Click on it and you will see the Save Image Settings options: "Camera Raw database" and "Sidecar '.xmp' files." These control where the Camera Raw adjustments, and a few other image settings imposed by Bridge, should be stored. If the database option is chosen, the adjustment goes on to somewhere in the system/user library. If the sidecar option is chosen, every time an adjustment is applied to a RAW file, an XMP file with the name of the RAW file is created. Have a look at the folder "Appendix Bridge Demo" from Windows Explorer (PC) or the Finder (Mac) and you will see something like **image A-8**. In this folder, the NEF files are now accompanied by XMP files with the same names. These are the sidecars that were created when we adjusted the Yellowstone shots.

How about the DNG files? Some of them have adjustments, yet there are no XMP files. This is because DNG files have built-in sidecars—which really sounds funny, doesn't it? These sidecars are not exactly "on the side."

So what is the rationale behind preferring the sidecar option over the database option? There are two reasons.

Image A-6. The symbol indicating that cropping has been applied. The thumbnail displays as the cropped image.

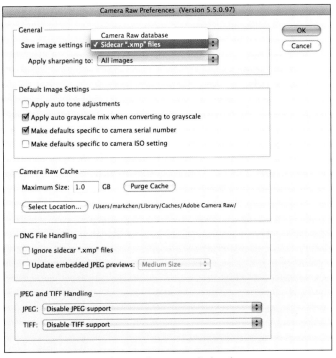

Image A-7. The Bridge Preferences dialog box.

First, the XMP files are conveniently located right with the RAW files, so they can be archived together to preserve the adjustments. If the database files are left behind when the RAW files are archived, the adjustments will be lost.

A second point, more marginal but rather interesting, is that XMP sidecars provide an opportunity for teamwork. Imagine there is one Camera Raw expert on a design team whose members are all working in geographically diverse locations. If each team member gets a copy of the RAW file, the Camera Raw expert can help the team by making any needed adjustments, producing XMP files, then sending (by e-mail, perhaps) all those XMP files to the other members. They can put those XMPs into their own folder—and voilà! The adjustments are applied. As indicated in **image A-8**, the XMPs are merely a few kilobytes—a tiny fraction of the size of a RAW file. They are easy to send around.

Another important setting is located at the bottom of the Preferences dialog box. These settings are about opening JPGs or TIFFs into Camera Raw. The hype was intense when this feature was introduced. I was dancing along with it . . . until the music suddenly died and I realized that the benefit of opening JPGs or TIFFs into Camera Raw is minimal. Let's use the food analogy again: If you are given the best USDA-graded ribeye steak, you can turn it into all kinds of dishes. If you are given a vacuum-packed, half-cooked, pre-seasoned patty, you can pretty much just make a hamburger. RAW has to be raw. A JPG is cooked and, therefore, not as good as RAW.

Cameras and Camera Settings: The Effect on RAW Files

After reading this book, you should have come to a full appreciation of what RAW images enable us to do. There is one string attached, though: RAW images are only as good as the cameras that produce them. If the images you deliver to the clients (or yourself—I am not neglecting the amateurs, here) are wines, then the RAW files are the grapes. What are the cameras? They are the vineyard, the farmers, and the grapevines.

Since we are so concerned about the quality of the images made from our RAW files, we should have some understanding of how cameras determine the quality of RAW images. With the help of Houston Camera Exchange, I put my hands on a few models—leaders at the time of this writing—for testing. This section is by no means a product review; the purpose is to provide you with information about how certain factors affect the quality of the RAW images.

In order to see the results unambiguously, all the test shots were conducted under controlled studio lighting, shooting a still-life setup of a color chart and sea shells, like **image B-1.**

We will make a comparison of RAW image quality based on camera settings, then examine considerations camera buyers often have in mind when choosing among the models on the shelf (or website, to be in tune with our era). Although it is very difficult for me to hold back, I will not elaborate on the reasons behind each phenomenon here; the theories have all been covered in previous chapters. So if you jumped to this section without covering the earlier parts of the book, tough luck. Be good and go read the rest of the book.

Image B-1. The setup of the test shots.

ISO SETTINGS

As with film, higher ISO settings yield lower digital image quality. Since digital noise lacks any appeal (unlike film grain, which at least looks somewhat "artsy"), we should try to use as low an ISO as possible. If you are shooting an outdoor concert on a midsummer's night, though, you do not have the luxury of using low ISOs. So what would you expect from the compromise? Let's compare high ISO shots and low ISO shots on a few different models.

Images **B-2** and **B-3** were shot on a Canon 5D Mk II at ISO 100 and ISO 6400 respectively. The luminance and chromatic noise is much more pronounced on the latter. Interestingly, the high ISO shot also provides higher contrast on the details of the bright shell. This is due to the fact that, when set at ISO 100, the highlights have to come from nearly the highest output of the sensor; at ISO 6400, the highlights are produced with only a fraction of the sensor's full output.

Image B-2. Canon 5D Mk II at ISO 100.

Image B-3. Canon 5D Mk II at ISO 6400.

Image B-4. Canon 5D Mk II at ISO 6400 without noise reduction.

Image B-5. Canon 5D Mk II at ISO 6400 with noise reduction.

Image B-6. Nikon D700 at ISO 6400, with noise reduction on "no."

Image B-7. Nikon D700 at ISO 6400, with noise reduction on "high."

NOISE REDUCTION

Many cameras offer high-ISO noise reduction and long-exposure noise reduction. Digital cameras really don't do long exposures well—I know that because I have made numerous (failed) attempts to shoot starry skies. This does not mean digital cameras can't do long exposures at all, but shooting conditions matter a lot and heavy postproduction might be necessary. The straight talk is this: if you want to avoid the noise resulting from long exposures, keep your exposures short! Let's focus on the more practical high-ISO noise reduction.

Images **B-4** and **B-5** were made on a Canon 5D Mk II at ISO 6400. **Image B-4** had no noise reduction; **image B-5** had strong noise reduction. The difference is most visible in the two shades of gray. It seems that the one with noise reduction has more randomized noise, whereas the one without noise reduction has visible horizontal line patterns. I can't say, though, that there is much improvement.

Images **B-6** and **B-7** were shot on a Nikon D700 at ISO 6400. **Image B-6** had the noise reduction set to "no"; **image B-7** had the noise reduction set to "high." The difference is still most prominent on the grays. Here, the one with noise reduction has very minute improvement in the chromatic noise.

Judging from these two cases, and a few other experiments that I am not presenting in this book, I conclude that high-ISO noise reduction does not provide a significant improvement.

Image B-8. *Nikon D700 at ISO 100 with one stop of overexposure.*

Image B-9. *Nikon D700 at ISO 100 with two stops of overexposure.*

Image B-10. *The Exposure slider set to –1.00 on the one-stop overexposed image.*

Image B-11. *The Exposure slider set to –2.00 on the two-stops overexposed image.*

HIGHLIGHT CLIPPING TOLERANCE

One of the raw powers of RAW images I bragged about in this book was the ability to recover overexposed images, or reduce highlight clipping. This ability depends on how many more stops of gray levels the RAW image has retained beyond the white point. One would assume that different camera models, with difference sensors and image processing, would yield different degrees of tolerance.

Keep in mind that this ability is not just helpful when we make a boo-boo. Very often, some objects in the shots are way brighter than the rest; in this case, hot spots become inevitable.

First let's check out how different ISO settings can affect this capability. **Images B-8** and **B-9** were shot on a Nikon D700 at ISO 100 with one and two stops of overexposure respectively. They were opened into Camera Raw with the Highlight Clipping Warning turned on, so you see hot spots indicated with red. Some of the color squares are almost entirely covered in red—don't mistake them for red color squares!

Image B-12. *The Exposure slider set to –4.00 on the two-stops overexposed image.*

After applying Exposure adjustments of –1.00 and –2.00 to these images, respectively, the results are shown in **images B-10** and **B-11**. As you can see, the one-stop overexposed image has most of the hot spots removed; the two-stop overexposed image still has many hot spots. Just for curiosity, **image B-12** shows how the two-stop overexposed image looks with the Exposure slider set all the way to –4.00. The hot spots stay. From this, we can conclude that when the

exposure is two stops over the correct setting, the highlights are quite likely to be blown into oblivion. (This is, of course, assuming the shot has an average contrast, like our setup here.)

An interesting question remains: How does the ISO setting affect the highlight-clipping tolerance? **Image B-13** was produced on a Nikon D700 at ISO 1600; it was about 1.5 stops overexposed. To see how much highlight clipping it has, **image B-14** is the same image with Highlight Clipping Warning turned on. In an attempt to recover the clipped highlights, the Exposure was reduced to –1.65, as indicated in **image B-15**. Almost all the reds are gone.

As we can see, shooting at a high ISO provides better highlight-clipping tolerance. This phenomenon is caused by using only a fraction of the maximum output signal as white, which allows a lot of data that was brighter than white to be preserved. So if we redefine what is white by reducing the exposure, these hidden sectors of the data slide right into the highlight area of the histogram.

While the conventional wisdom tells us to use low ISO settings for better image quality, this test reveals that blown-out hot spots can actually be better fixed when working with a high ISO shot. Testing of other Nikon models and cameras of other brands yields a similar result.

If we use marriage as an analogy, the low ISO shots are like having full knowledge of your future spouse before taking the vow; while his/her good qualities (looking at the bright side) are fully appreciated, there will be few surprises after the union is made. High ISO shots are like marrying Mr. or Ms. Right without knowing it; a lot more greatness reveals itself after the wedding. Both cases are nice, aren't they?

COMPRESSED *vs.* UNCOMPRESSED

Some brands, including Nikon, provide different compression modes for the RAW file. Compressed and uncompressed Nikon RAW (NEF) files can vary greatly in their sizes. On average, the compressed files are about half the size of the uncompressed ones—great news for shooters in the field.

Upon close examination of the compressed and uncompressed NEF files, no discernible quality difference can be spotted. The comparisons I have made include the noise level, fine details, contrast, and highlight clipping tolerance.

So how on earth does a file shed half of its data without a loss of quality? This has something to do with a process called demosaicking. Let's not get too nerdy by talking

Image B-13. Nikon D700 at ISO 1600, 1.5 stops overexposed.

Image B-14. The Highlight Clipping Warning for this image.

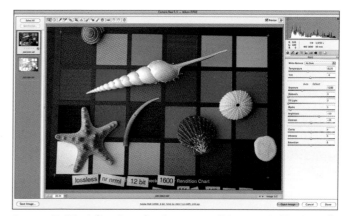

Image B-15. Adjusting the Exposure slider to –1.65 virtually eliminates the clipping.

about what demosaicking is—what you need to know is that demosaicking turns out to be a necessary process in making an image ready. So, using the uncompressed mode is sort of using a RAW that is unnecessarily raw. (I like my steak rare, but please ask the chef not to skip the entire cooking process—put it in a pan.)

Get the picture? The larger size of an uncompressed RAW file does not provide any advantage, so feel free to use compressed RAW files.

12-BIT VS. 14-BIT

Nikon started making 14-bit color depth available on their higher-end models before this book was written, making the already populous Nikon camera menu explode with possible combinations!

Color depth can be viewed as how fine the gray levels are that the camera assigns to the electronic signals from its sensor. A 12-bit image has 2^{12} levels, which is 4,096 levels. A 14-bit image has 2^{14}, which means 16,384 levels.

But can our eyes tell the difference between 4,096 gray levels and 16,384 gray levels? Not for me—and not for a normal human. Eventually, though, there might be genetically superior human species that can. When that happens, Nikon will certainly have an advantage.

Now, this is all based on average shooting circumstances. But what if an image is seriously underexposed? In order to make the image usable, Camera Raw's Exposure slider needs to be increased drastically. This means a small range

Image B-16. 14-bit Nikon D700 image at ISO 100 with two stops underexposure and +4.00 Exposure adjustment in Camera Raw.

Image B-17. 12-bit Nikon D700 image at ISO 100 with two stops underexposure and +4.00 Exposure adjustment in Camera Raw.

of gray levels might need to be stretched to cover the whole range. For example, imagine we need to take the lowest quarter of the gray levels and stretch them to cover from black to white. With a 12-bit image, this will mean stretching out 1,024 gray levels (a quarter of the total 4,096 gray levels). With a 14-bit, we'd have 4,096 gray levels to work with (a quarter of the total 16,384 gray levels). One would assume the latter would yield a much finer gradation.

Let's compare two images taken on a Nikon D700 at ISO 100 with 12-bit and 14-bit color depth. Both were shot with two stops of underexposure (**images B-16** and **B-17**). Then, in Camera Raw, the Exposure slider was pushed all the way to +4.00. Scanning the whole image, I found the only visible differences were in one area: the shadows. **Images B-18, B-19** and **B-20** are a few examples where visible differences were spotted. The left image is 14-bit and the right one 12-bit. The 14-bit image has very, very slight advantage in the gradation of shadows. You can also see these are very zoomed in.

Keep in mind that the difference only becomes barely visible when increasing four stops of exposure on a two-stop underexposed image. I had to go to extremes in stretching the gray level to make the difference visible. Therefore, I conclude that the benefit is negligible.

Images B-18, B-19, and B-20. A few examples of visible difference between 14-bit image (left) and 12-bit image (right).

CAMERA BRANDS: HEAD TO HEAD

I am sure this gets many people excited. I almost feel like a sports commentator when the comparison comes to the brands. Be it wars, sports, or political parties, people are so excited about choosing sides that even camera brands can stir their competitive spirit. While some of this side-choosing involves personal beliefs, when it comes to camera brands, don't be silly; buy whatever serves you best.

I tested a few models that were considered the core of the fleet at the time of this writing. These models were not the $5000+ cameras reserved exclusively for the pros. They were also not the entry-level $1000-and-under models. The

Image B-21. Nikon D700 at ISO 100.

Image B-22. Canon 5D Mark II at ISO 100.

Image B-23. Olympus E3 at ISO 100.

Image B-24. Sony Alpha 850 at ISO 100.

Image B-25. Nikon D700 at ISO 1600.

Image B-26. Canon 5D Mark II at ISO 1600.

Image B-27. Olympus E3 at ISO 1600.

Image B-28. Sony Alpha 850 at ISO 1600.

models tested are the Nikon D700, the Canon 5D Mark II, the Olympus E3, and the Sony Alpha 850.

The first set of comparisons are ISO 100 shots (**images B-21** to **B-24**). Besides some white balance differences, which can be adjusted, no clear advantage exists.

Images B-25 to **B-28** are images from the same cameras set at ISO 1600. The differences are becoming much more prominent. Look for the noise. While the D700 and 5D keep the noise at acceptable levels, the Alpha 850 and E3 have produced noise that would compromise the image quality.

Image B-29. *Nikon D700 at ISO 1600 with maximum noise reduction applied in Camera Raw.*

Image B-30. *Canon 5D Mark II at ISO 1600 with maximum noise reduction applied in Camera Raw.*

Image B-31. *Olympus E3 at ISO 1600 with maximum noise reduction applied in Camera Raw.*

Image B-32. *Sony Alpha 850 at ISO 1600 with maximum noise reduction applied in Camera Raw.*

Now we will see what Camera Raw can do to these images. After applying full-power noise reduction (100 for Luminance and 100 for Color—which is, of course, something you shouldn't try at home, kids), we come to **images B-29** through **B-32**. Here, we are looking for the effectiveness of removing noise while preserving details. While the D700 and 50D images score well on these criteria, the E3 and Alpha 850 images are looking fuzzy with remnants of noise.

The following comparison consists of disturbing images. Viewer discretion is advised. These shots were taken at the maximum rated ISO (that means the camera assigns a figure to the ISO, rather than just calling it "high") with two stops of underexposure. The images were then adjusted in Camera Raw to regain the correct exposure. In other words, these are the cameras at their very worst. I don't think any sensible photographer would voluntarily use a camera in this manner. However, these images do reflect the image quality you might have to deal with when photographing a wedding in a poorly lit church that does not allow flash.

So here they are. **Images B-33** through **B-36** are the shots made under the aforementioned conditions. The ISO settings were all 6400, except the image from the E3, which was set to the camera's maximum ISO of 3200. I will leave all judgement to be made by you, the reader.

Image B-33. Nikon D700 at ISO 6400 with two stops underexposure. In Camera Raw, the Exposure slider was adjusted to +2.00.

Image B-34. Canon 5D Mark II at ISO 6400 with two stops underexposure. In Camera Raw, the Exposure slider was adjusted to +2.00.

Image B-35. Olympus E3 at ISO 3200 with two stops underexposure. In Camera Raw, the Exposure slider was adjusted to +2.00.

Image B-36. Sony Alpha 850 at ISO 6400 with two stops underexposure. In Camera Raw, the Exposure slider was adjusted to +2.00.

THEN AND NOW

How about the progress within a brand? How would something you bought five years ago compare to a current model? For this consideration, I worked with a Nikon D700 and a Nikon D2X. Here, low ISO shots do not declare any clear winner. However, at ISO 1600—the D2X's highest rated setting—the difference is clear. **Images B-37** and **B-38** reveal the progress Nikon made in just five years. The D2X was priced at above $5000 at the time. Today, the D700 is at the $3000 level.

So, while my Nikon FE cameras (for very young readers: these cameras shoot film) are still operable after thirty years, the digital era has technologically junked a camera model within just a few years. They don't make things like they used to? The old expression now sounds ambiguously true and false the same time.

PIXEL DENSITY

This comparison is based on a combination of two factors: the total number of pixels (the megapixels [MP]) and the size of the sensor. (*Note:* The most common sensors sizes are the DX format [23.6 x 15.8mm] and the full-frame format [36 x 24mm; the size of a 35mm film frame].) Dividing the former by the latter we get pixel density, which describes how tightly the pixels are arrayed on the sensor. Obviously, larger number of pixels yield higher densities, while larger sensors yield lower densities.

Lower density has a positive impact on image quality because it means that larger photosites (the units responsible for creating each pixel) can be fitted. Larger photosites mean higher charge outputs—or a larger number of electrons. This, in turns, leads to a higher signal-to-noise ratio. In other words: lower pixel densities mean less noise.

Image B-37. Nikon D700 at ISO 1600.

Image B-40. D700 at ISO 1600 (pixel density of 3.3MP/cm²).

Image B-38. Nikon D2X at ISO 1600.

Image B-39. Nikon D300 at ISO 1600 (pixel density of 1.4MP/cm²).

Images **B-39** and **B-40** were shot with a Nikon D700 and a Nikon D300s at ISO 1600. Both cameras have 12MP sensors. However, the D700 has a full-frame sensor (giving us a pixel density of $1.4MP/cm^2$), while the D300s has a DX-format sensor (giving us a pixel density of $3.3MP/cm^2$). Comparing the images, it is clear to see the benefit of the full-frame sensor when it comes to noise.

There are, however, other considerations. For example, the larger full-frame sensor challenges the quality of the lens more because retaining optical precision at the edge of the image is more difficult. On the other hand, the DX sensor sits nicely in the "sweet spot" of the lens. (More detail on this is beyond the scope of the book, so I will keep it for another writing endeavor—stay tuned, folks!)

One very important lesson here is that the megapixel craze does have a negative impact because a higher number of pixels increases the pixel density. You may have paid more to get a higher resolution, but more noise follows. More bucks for more noise? That might be unwise.

PRICE TAG

Are you getting what you paid for? As a professional, one major concern regarding a camera model is how durable it is. Without any exception that I know of, all camera makers put more alloy in their expensive cameras and more plastic in their cheaper camera—so you can imagine the difference when you drop them. I once witnessed a wedding photographer, forgetting that the camera strap was not on his shoulder, clap when the father of the bride finished a speech. The clunk was loud, but he picked up the camera and went on shooting (although with a blush, I must add). I maintain a thirty-year history of not dropping my camera once—knock on wood.

Okay, so this has gone way off topic, but I thought it was both valuable and entertaining. Before we conclude, let's compare a couple of Nikon models: the D40 and the D700. These two models are contemporary, yet the D40 is in the $500 range, while the D700 will run you about $3000. ISO 100 shots? You guessed it: no significant difference. At ISO 1600, the highest D40 goes, the comparison is seen in **images B-41** and **B-42**.

Image B-41. Nikon D40 at ISO 1600.

Image B-42. Nikon D700 at ISO 1600.

APPENDIX C

Converting Proprietary RAW Files to DNG Files

CONVERTING INSIDE CAMERA RAW

When a RAW file is opened into Camera Raw, look for the Save Image button at the bottom left corner of the dialog box, as illustrated in **image C**-1. Click on it and you will get a dialog box like **image C-2**.

This should be a very self-explanatory dialog box. It is for us to determine where the file should be saved, under what name it will be saved, and the format in which it will be saved.

Obviously, the format options are the ones worth more discussion here. Besides choosing the digital negative (DNG)

Image C-3. The tool tip for the Compatibility menu.

Image C-4. The progress indicator appears while the files are being saved.

Image C-1. Click to go to the Save Image dialog box.

Image C-2. The Save Image dialog box.

format, there is also a Compatibility pull-down menu. If you move the cursor to that pull-down, an unusually long tool tip pops up—as seen in **image C-3**.

I find my reading speed inadequate for the briefness of the tool tip. But you can take your time reading the screen shot on this page. The content is rather interesting. It seems to imply that DNG files are mostly backward compatible (in layman's terms: able to be opened by an older version of Camera Raw). It might depend on the camera model. One assumes that a very recent camera model will produce a RAW file that, once converted to a DNG, could cause more problems regarding backward compatibility. If you do not have a concern regarding this, always use the latest version.

The last check box is rather interesting, too. If you check Embed Original RAW File, you will find the converted

DNG is more than twice the size of a DNG file without this option. Obviously, something has been stuffed into it. What is it? We will see in the next section.

When all settings are set and all options are opted, click Save and a progress indicator will present itself next to the Save Image button, as in **image C-4**. When it is done, the indicator disappears.

ADOBE DNG CONVERTER

Converting to DNG from inside Camera Raw has not been something I found useful—until I was preparing the files for this book. This is because my projects often require the conversion of thousands of files at a time. If you have similar needs, it is recommended that you use Adobe DNG Converter. This can be downloaded at no cost from Adobe.com. Once it is installed on your computer, look for an icon like **image C-5**. The DNG Convertor's interface looks like **image C-6**. Again, all the items here should be self-explanatory. The compatibility issue and the option to embed the original RAW are addressed in the Preferences section of this dialog box. Use the same considerations as explained earlier.

Image C-5. The program icon for Adobe DNG Converter.

If you have ever chosen to embed the original RAW files in your DNG files, the Extract button is where you initiate the reversal process—to get the proprietary RAW files back out. Using this process, you can find out what was engulfed by the python.

Image C-6. The DNG Converter dialog box.

APPENDIX D
Quiz Answers

QUIZ 1 ANSWERS

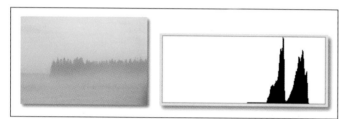

Image D-1. Photograph 1, Histogram C.

Image D-2. Image 2, Histogram E.

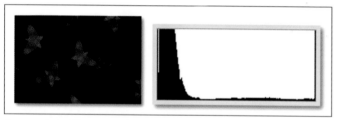

Image D-3. Photograph 3, Histogram F.

Image D-4. Photograph 4, Histogram B.

Image D-5. Photograph 5, Histogram A.

Image D-6. Photograph 6, Histogram D.

Further Discussion on Histograms. Can you verbalize the relationships between the images and their histograms? Let's try 1-C (**image D-1**). In this foggy scene, all of the pixels are brighter than the midtone, which explains the total lack of histogram structure to the left side of the midtone point. Further examination shows that the sky is a major group, with overall similar brightness, which also forms the brightest area. It is responsible the right-most peak. But since it is not entirely bright, the peak is somehow darker than white. The water and the trees form the other peak, which contains tones that are darker and larger in number. Try to do the same to all other pairs. (And here's a special challenge: What is the difference between 3-F [**image D-3**] and 4-B [**image D-4**]?)

Image D-7. Original image.

Image D-8. Photograph 1, Curve D.

Image D-9. Photograph 2, Curve A.

Image D-10. Photograph 3, Curve E.

Image D-11. Photograph 4, Curve B.

Image D-12. Photograph 5, Curve F.

Image D-13. Photograph 6, Curve C.

Further Discussion on Tone Curves. Again, can you verbalize your explanations of these image/curve pairings? Curve F (**image D-10**) creates a perfect negative image. If you are younger than twenty, chances are that you have not used film, but trust me—photograph 5 (**image D-12**) looks just like the negative image of the original, with reversed brightness levels and colors. I will totally accept your explanation for 4-B (**image D-11**) if you simply said that the wackiest tone curve must produce the wackiest image! A tone curve like B would turn the image into a partial positive and negative.

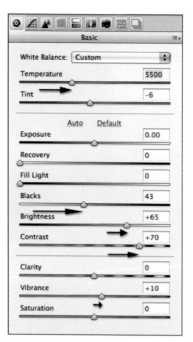

Image D-13 (top left). The original image.

Image D-14 (top right). The corrections applied to the sand dunes image.

Image D-15 (bottom). The final image.

QUIZ 2 ANSWERS

Sand Dunes Image. This image of the White Sand National Park was shot with the wrong white balance setting—which ruined the very color in the park's name. The first thing I did was pull the Temperature slider up to daylight—about 5500K. To increase the contrast, I moved the Brightness slider to +65, then increased the Contrast slider to +70, spreading out the histogram. To pull the left edge of the histogram closer to the black point, I increased the setting of the Black slider to 43. Finally, I increased the Vibrance slider to + 10 to enhance the color (**image D-14**).

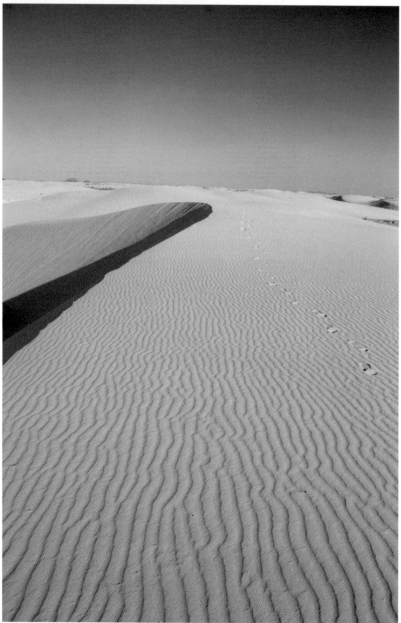

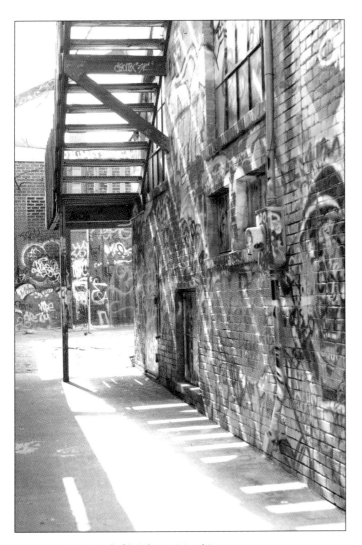

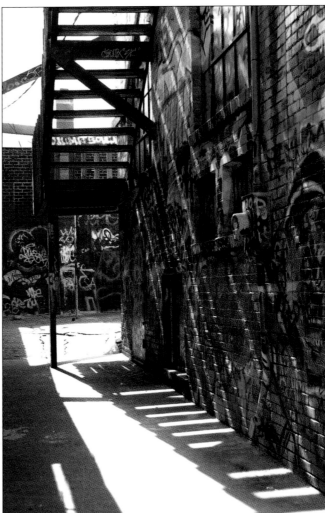

Image D-16 (top left). The original image.

Image D-17 (right). The corrections applied to the graffiti image.

Image D-18 (top right). The final image.

Graffiti Image. This is a shot of an fascinating artists alley in Rapid City, SD. The image is quite overexposed, so there are many hot spots. The details of the graffiti are kind of lost. To fix this image, I first dropped the Exposure slider to –1.50 and brought the Recovery slider up to 40. These two adjustments restored lots of the blown-out highlights. After this adjustment, the image looked dark, so I brought the Brightness slider up to 80. The shadows looked kind of wishy-washy. To bring them back, I brought the Blacks slider up to 40. This nicely connected the left edge of the histogram to the black point. Bringing the Contrast slider up to +40 and the Vibrance slider up to +30 added some drama to the image (**image D-17**). Voilà!

Sunset Image. My subject here was a dramatic October sky—somewhere between Casper, WY, and Yellowstone. The scene was so contrasty that most of the details fell off the range of the histogram. Therefore, my goal was to bring some blueness back to the sky and some definition to the clouds. Pulling the Exposure slider down to –0.75 and bumping the Recovery slider up to 80 brought back lots of details in the "silver linings" of the cloud. Next, I moved the Brightness slider up to +106 to send more pixels from the shadow range up to the midtone range. I also dropped the Contrast slider all the way down to –50. Because all of the above steps are neutralizing, the colors were quite neutralized, too. Bringing the Saturation up to +25 restored the colors (**image D-20**). You might notice the not-so-pretty noise in the dark parts of the cloud; read chapter 6 to learn how to deal with this problem.

Image D-19 (top left). The original image.

Image D-20 (top right). The corrections applied to the sunset image.

Image D-21 (bottom). The final image.

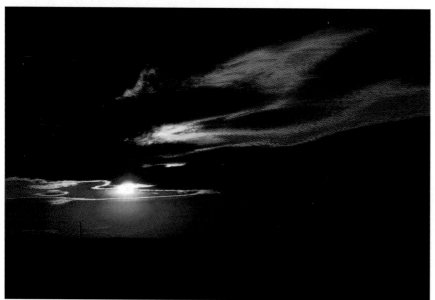

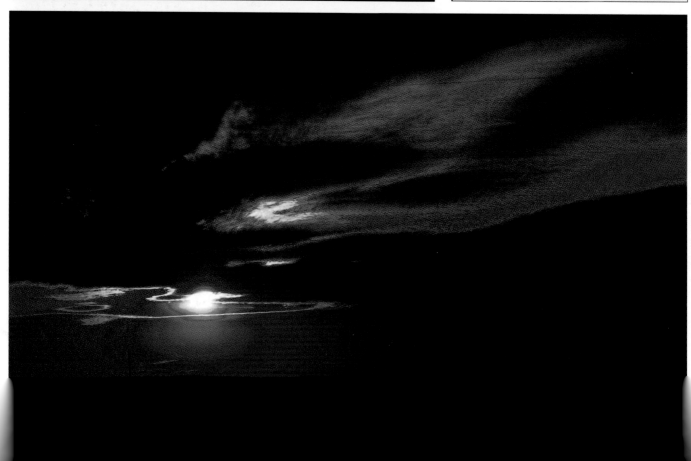

Image D-22 (top right). The original image.

Image D-23 (top left). The corrections applied to the sunset image.

Image D-24 (bottom). The final image.

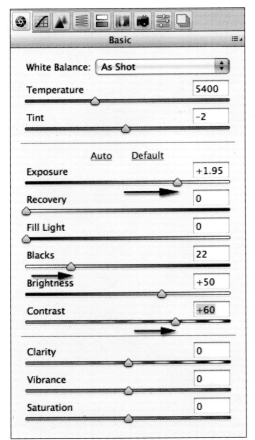

Waterfall Image. The mist at Niagara Falls is to blame for this very flat image. The histogram has no structure whatsoever in the right one-third and left one-fifth of the brightness range. It is very flat indeed. First, I increased the Exposure slider to +1.95 to make the white water white—without blowing it out. Then, I brought the Blacks slider up to 22, stretching the left edge of the histogram to near black. After these adjustments, the color of the sky and the greenness of the water were much better. A final touch was to bring the Contrast up to +60, further separating the highlights and shadows (**image D-23**).

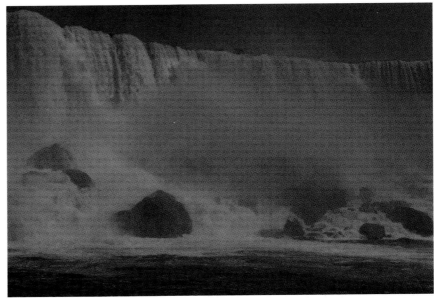

Image D-25. *The original image.*

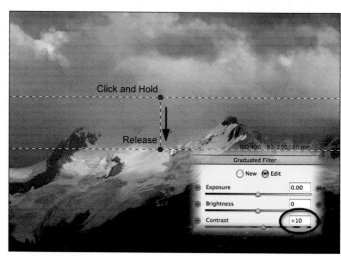

Image D-26. *The initial Graduated Filter setting and where to place it.*

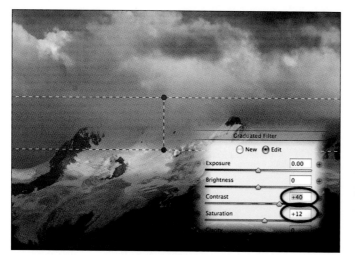

Image D-27. *Adjusting the settings on the Graduated Filter.*

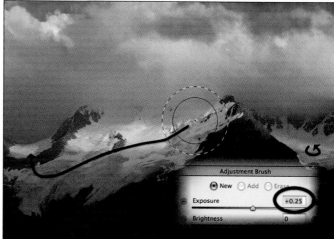

Image D-28. *The initial settings of the Adjustment Brush, the size of the brush, and the brush strokes.*

QUIZ 3 ANSWERS

To dramatize the sky, I used the Graduated Filter to gradually increase the amount of adjustment toward the upper end of the image.

I picked the Graduated Filter by clicking on its button, then dragged the Contrast to +10 before placing the gradient (remember, you must enter a setting first; I picked a contrast adjustment because it might be needed anyway). Then, I placed the gradient by clicking slightly above the peak, dragging downward, and releasing the click slightly below the peak, as illustrated in **image D-26**.

Next, I adjusted the Contrast setting to +40 and the Saturation to +12. This was sufficient to improve the image without an exaggerated look (**image D-27**). This took care of the sky.

Next, I used the Adjustment Brush to increase the high-lights on the glacier. First, I increased the overall brightness

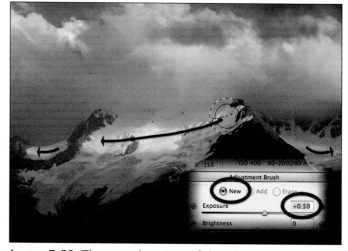

Image D-29. *The second settings of the Adjustment Brush, the size of the brush, and the brush strokes.*

Image D-30. *Setting the Color Picker for the third Adjustment Brush application.*

Image D-31. *The third settings of the Adjustment Brush, the size of the brush, and the brush strokes.*

Image D-32. *Erasing some over-painting.*

Image D-33. *Hovering the cursor over the third application pin to evaluate the coverage.*

on the entire glacier. I set the bush as indicated in **image D-28**, adjusted the Exposure to +0.25, then applied strokes as indicated in the same image.

I then reduced the brush size, as indicated in **image D-29**, set the Exposure to +0.50, clicked the radio button to New, and applied strokes as indicated in the same image. Remember, the Adjustment Brush does not accumulate effects, so the second stroke only overwrites the first; it does not add to it.

It was time to deal with the blue hue on the hill. I set the radio button to New, clicked on the box next to Color, and set the Color Picker as indicated in **image D-30**. After clicking OK to close the dialog box, I set the brush as indicated in **image D-31**, then applied the stroke.

Examining the Preview, I determined that a Saturation setting of 20 did not seem to kill the blue hue entirely, so I summoned the Color Picker dialog box again and increased the Saturation to 40, which seemed to suffice. However, I found myself painting over some of the blue hue-shift fix on the glacier, which made some of the glacier area yellowish. (It looked as if some gigantic monster had been using the restroom there!) It was time to use the Erase mode of the Adjustment Brush.

I clicked OK on the Color Picker to dismiss it, then made sure the current active Pin was the one with the blue hue adjustment. In my case, it was the one located farthest to the right in **image D-32**. (This is the one with a dot, which means it is active. If it is not active, move your cursor to

Image D-34. The final image.

it and click on it.) I checked the Erase radio button and applied the strokes indicated in **image D-32**. This fixed my over-painting. You may need to apply strokes in other areas—wherever they are required.

To make sure there was no more stain left by the monster, I placed my cursor on the pin and checked out the foggy indicator, as illustrated in **image D-33**. Since I didn't see any fog on the glacier, I proclaimed Operation Glacier Wiping a success. Clicking Open Image, my final photograph looks like **image D-34**. Awesome!

QUIZ 4 ANSWERS

In this imaging solution, I will apply the techniques covered in chapters 4, 5, and 6. I opened "sanitizer.dng" into Camera Raw.

First, I set the adjustment to brighten the foreground. I increased the Exposure to +0.90, giving me a completely white background and a brightened foreground without creating hot spots on the edge of the hands, as illustrated in **image D-37**. The brightness of the foreground still has more

Image D-35. The "sanitizer.dng" image opened into Camera Raw. The arrow indicates an area that needs some brightening.

Image D-36. Noise is visible on the hand.

to be desired, but applying more Exposure or Brightness will compromise the look of the main subjects.

Since the brightness on the foreground changes gradually toward the lower part of the image, the Graduated filter came to mind. I activated it and set the Exposure to +1.50. Then I placed the gradient as shown in **image D-38**. This improved the foreground brightness but blew out the interesting details inside the bottle. The global Exposure setting of +0.90 also blew out the outline of the bottle. We certainly do not want to lose the details on this main attraction.

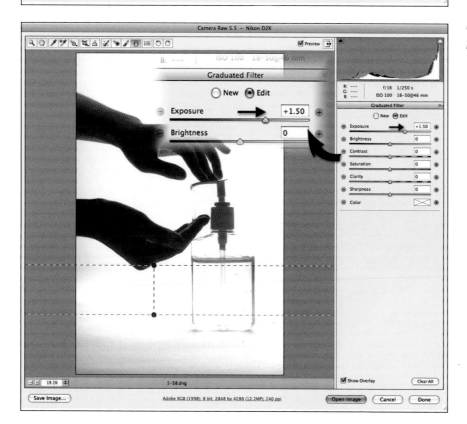

Image D-37. Increasing the brightness in the foreground and background.

Image D-38. Adding the Graduated filter for foreground adjustment.

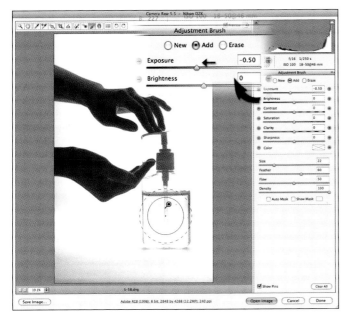

Image D-39. Adjusting the bottle with the Adjustment Brush tool.

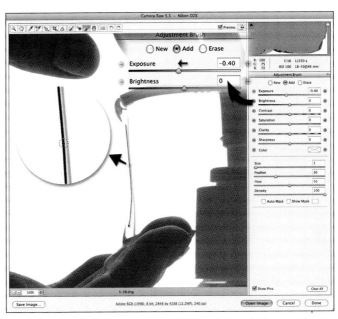

Image D-40. Recovering details in the gel flow with the Adjustment Brush.

To reduce the effect of the prior two steps, I used the Adjustment Brush tool. One very important thing to keep in mind is that global adjustments do not accrue with either the Graduated filter or the Adjustment Brush tool, but they do cancel each other. Therefore, I activated the Adjustment Brush tool. I set the Exposure to –0.75, set the brush to something like **image D-39**, and applied the brush to the bottle. With this stroke, the bubbles reappeared in the bottle, which also began to look more three-dimensional again. Because the effect of the Adjustment Brush and the Graduated filter cancel each other, the bottle now has an Exposure adjustment around +0.75 (1.50 – 0.75 = 0.75).

Next, I accentuated the dispensing gel. First, I zoomed in to the area. I picked up the Adjustment Brush, set the Exposure to –0.40, and set the brush to a tiny size, as seen in **image D-40**. I put the brush at the top portion of the gel flow, then clicked and held to brush down over the dripping gel. When this was done, the gel was much more prominent and had a more three-dimensional feel, like **image D-41**.

These steps set up a good base for the image. In order to maintain my ability to make additional changes in Camera Raw, I next opened the image into Photoshop as a Smart Object (by pressing Shift and clicking Open Object).

Next, I needed to deal with the noise on the hands. Noise reduction should be only applied locally (so it will not reduce the sharpness in areas that do not need noise reduction), so I decided to create another Smart Object and use layer masks for selective displaying.

Image D-41. The gel flow after adjustment.

I opened "sanitizer.dng" again into Camera Raw. Then I activated the Adjustment Brush and clicked on the Clear All button at the bottom of its adjustments. I did the same for the Graduated Filter. Then I activated the Zoom tool and set the Exposure slider at +0.75, which put the hands at the right brightness.

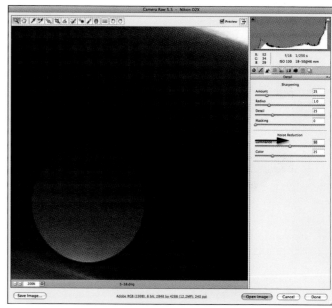

Images D-42 and D-43. Dark areas of the hand before and after noise reduction (the circled areas have been enlarged and brightened to show the difference).

Image D-44. Placing the two images as layers.

Image D-45. Renaming layers in a more meaningful manner.

I zoomed in to 200 percent and panned to the lower side of the left wrist, where the noise was most prominent, then clicked on the Detail tab. Under Noise Reduction, I dragged the Luminance slider around through the whole range and observed the change in the noise. Since this shot was made at ISO 100, the noise was not severe. A Luminance setting of 50 sufficed. **Images D-42** and **D-43** show the difference—before and after the noise reduction.

I opened this image as a Smart Object in Photoshop (by pressing Shift and clicking Open Object), then activated the Move tool. While holding Shift (to align the layers), I dragged the new image into the image I opened previously. Both of the layers had the same name (not a beacon of clarity in this world of confusion), so I double-clicked on the top layer and changed it to "hands." I changed the name of the

bottom layer to "bottle and background," as indicated in **image D-45**.

I needed to create a selection of the hands to convert to a mask for the "hands" layer. In this image, only the hands have colors; the rest is nearly black & white. What better choice of tools would there be than the Color Range function? I went to Select>Color Range. This activated the dialog box seen in **image D-46** (except that the settings might be different). I set the Fuzziness to 20 and checked Localized Color Clusters. Then, on the right, I clicked on the Eyedropper symbol with a plus sign for "Add to Sample." The settings looked like **image D-47**.

I move the eyedropper cursor onto the image and placed it on the hand. Clicking and holding, I started moving the cursor around the hands. (All the time, watch closely what

Image D-46. The Color Range dialog box.

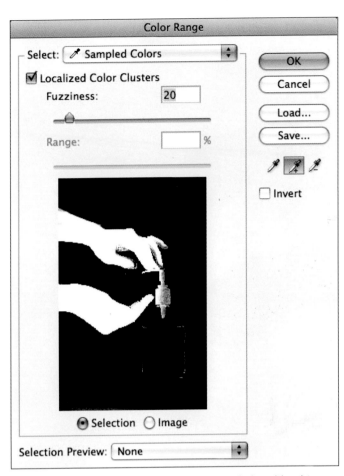

Image D-47. The Color Range selection ended up like this.

happens in the preview; you should see the white area adding up to cover the hands. Be careful not to move the cursor out onto the background, as that will lead to over-selection. If an accident happens, Alt/Opt click the Reset button.)

In my final selection, some parts of the bottle were selected, but that was fine with me—these darker areas on the bottle needed some noise reduction, too. I clicked OK to accept the selection (**image D-48**).

In my attempt here, a tiny part of the foreground at the bottom left corner was also selected. This is not welcomed, because I had already applied brightness adjustment here on the "bottle and background" layer, which will be showing at this area. Any revealing of the "hand" layer at this spot will be very out of place. So this selection had to be erased. A quick way to do this, at this stage, was to use the Quick Mask. (I am usually not a big fan of this method, but it comes in handy in certain circumstances.) I pressed Q to see the image like **image D-49**. In Quick Mask mode, red means "not selected," and the lower left corner was not red enough. I pressed B to pick up the Brush tool. I set the foreground color to black and the brush size around 600. I

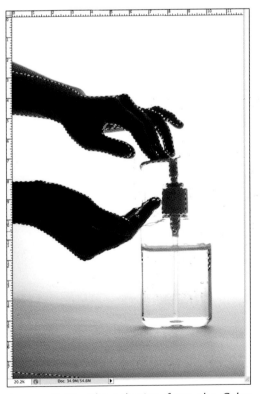

Image D-48. The selection from the Color Range is now on the layer.

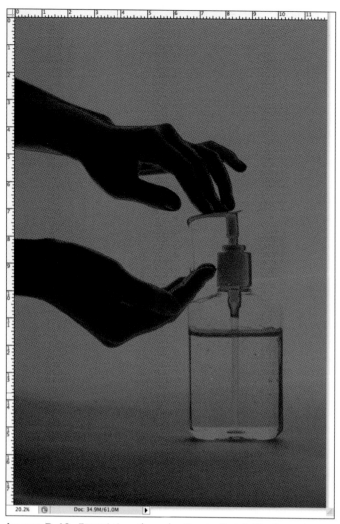

Image D-49. Examining the selection in Quick Mask mode.

Image D-50. Deselecting some of the foreground area with the Brush tool set to paint black.

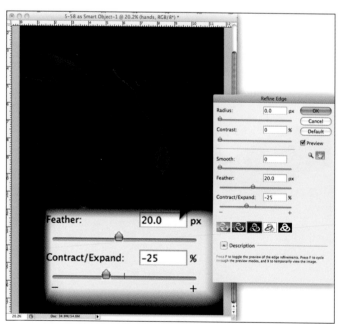

Image D-51. Applying Refine Edge to the selection.

Image D-52. The selection after Refine Edge is applied.

painted on the lower left corner until that area had redness like its surrounding (**image D-50**). I pressed Q to toggle off the Quick Mask off, revealing the selection—without any marching ants at that corner.

Next, I used Refine Edge to ensure that the transition would be not too sudden and that noise reduction would not apply to the border between the hands and the background (where sharpness is first priority). I went to Select>Refine Edge to bring up the dialog box. I found the setting in **image D-51** produced an ideal selection for these criteria. Contracting –25 is essential for keeping the noise reduction away from the edge of the hands. I clicked OK to accept the settings. The selection looked like **image D-52**.

Finally, I went to the Layers palette, made sure the "hands" layer was selected, and clicked on the Add Layer Mask button. This created the mask for the "hands" layer.

The final image looks like **image D-53**. The brightness is where we want it and the noise is reduced without noticeably compromising the sharpness. The benefit of the noise reduction might not be very visible in our illustration here, but in the cases of large prints (or if the image needed to be enlarged for a different composition) this improved quality makes a world of difference.

Image D-53. The very fine-tuned image.

Index

OTHER BOOKS FROM
Amherst Media®

ROLANDO GOMEZ'S
Lighting for Glamour Photography
In this book, renowned glamour guru Rolando Gomez teaches the simple and complex lighting strategies you need to create the figure-enhancing shots that will make every woman look her very best. *$34.95 list, 8.5x11, 128p, 150 color images, index, order no. 1918.*

TUCCI AND USMANI'S
The Business of Photography
Damon Tucci and Rosena Usmani

Take your business from flat to fantastic using the foundational business and marketing strategies detailed in this book. *$34.95 list, 8.5x11, 128p, 180 color images, index, order no. 1919.*

CHRISTOPHER GREY'S
Advanced Lighting Techniques
Learn how to create twenty-five unique portrait lighting effects that other studios can't touch. Grey's popular, stylized effects are easy to replicate with this witty and highly informative guide. *$34.95 list, 8.5x11, 128p, 200 color images, 26 diagrams, index, order no. 1920.*

THE DIGITAL PHOTOGRAPHER'S GUIDE TO
Light Modifiers
SCULPTING WITH LIGHT™
Allison Earnest

Choose and use an array of light modifiers to enhance your studio and location images. *$34.95 list, 8.5x11, 128p, 190 color images, 30 diagrams, index, order no. 1921.*

JOE FARACE'S
Glamour Photography
Farace shows you budget-friendly options for connecting with models, building portfolios, selecting locations and backdrops, and more. *$34.95 list, 8.5x11, 128p, 180 color images, 20 diagrams, index, order no. 1922.*

Multiple Flash Photography
OFF-CAMERA FLASH TECHNIQUES FOR DIGITAL PHOTOGRAPHERS
Rod and Robin Deutschmann

Use two, three, and four off-camera flash units and modifiers to create photos that break creative boundaries. *$34.95 list, 8.5x11, 128p, 180 color images, 30 diagrams, index, order no. 1923.*

CHRISTOPHER GREY'S
Lighting Techniques for Beauty and Glamour Photography
Create evocative, detailed shots that emphasize your subject's beauty. Grey presents twenty-six varied approaches to classic, elegant, and edgy lighting. *$34.95 list, 8.5x11, 128p, 170 color images, 30 diagrams, index, order no. 1924.*

UNLEASHING THE RAW POWER OF
Adobe® Camera Raw®
Mark Chen

Digital guru Mark Chen teaches you how to perfect your files for unprecedented results. *$34.95 list, 8.5x11, 128p, 100 color images, 100 screen shots, index, order no. 1925.*

BRETT FLORENS'
Guide to Photographing Weddings
Brett Florens travels the world to shoot weddings for his discerning clients. In this book, you'll learn the artistic and business strategies he uses to remain at the top of his field. *$34.95 list, 8.5x11, 128p, 250 color images, index, order no. 1926.*

JEFF SMITH'S
Studio Flash Photography
This common-sense approach to strobe lighting shows working photographers how to master solid techniques and tailor their lighting setups to individual subjects. *$34.95 list, 8.5x11, 128p, 150 color images, index, order no. 1928.*

Just One Flash
A PRACTICAL APPROACH TO LIGHTING FOR DIGITAL PHOTOGRAPHY
Rod and Robin Deutschmann

Get down to the basics and create striking images with just one flash. *$34.95 list, 8.5x11, 128p, 180 color images, 30 diagrams, index, order no. 1929.*

WES KRONINGER'S
Lighting Design Techniques
FOR DIGITAL PHOTOGRAPHERS
Design portrait lighting setups that blur the lines between fashion, editorial, and traditional portrait styles. *$34.95 list, 8.5x11, 128p, 80 color images, 60 diagrams, index, order no. 1930.*

DOUG BOX'S
Off-Camera Flash
TECHNIQUES FOR DIGITAL PHOTOGRAPHERS
Master off-camera flash, alone or with light modifiers. Box teaches you how to create perfect portrait, wedding, and event shots, indoors and out. *$34.95 list, 8.5x11, 128p, 345 color images, index, order no. 1931.*

How to Create a High Profit Potography Business in Any Market, 2nd Ed.
James Williams

Timeless advice for maximizing your marketing efforts and providing top-notch customer service. *$34.95 list, 8.5x11, 128p, 150 color images, index, order no. 1933.*

500 Poses for Photographing Men
Michelle Perkins

Overcome the challenges of posing male subjects with this visual sourcebook, showcasing head-and-shoulders, three-quarter, full-length, and seated and standing poses. *$34.95 list, 8.5x11, 128p, 500 color images, index, order no. 1934.*

500 Poses for Photographing Women
Michelle Perkins

A vast assortment of inspiring images, from head-and-shoulders to full-length portraits, and classic to contemporary styles—perfect for when you need a little shot of inspiration to create a new pose. *$34.95 list, 8.5x11, 128p, 500 color images, order no. 1879.*

On-Camera Flash
TECHNIQUES FOR DIGITAL WEDDING AND PORTRAIT PHOTOGRAPHY

Neil van Niekerk

Use on-camera flash to create lighting that flatters your subjects—and doesn't slow you down on location shoots. *$34.95 list, 8.5x11, 128p, 190 color images, index, order no. 1888.*

JEFF SMITH'S
Senior Portrait Photography Handbook

Improve your images and profitability through better design, market analysis, and business practices. *$34.95 list, 8.5x11, 128p, 170 color images, index, order no. 1896.*

JERRY D'S
Extreme Makeover Techniques
FOR DIGITAL GLAMOUR PHOTOGRAPHY

Bill Hurter

Learn the secrets of creating glamour images that bring out the very best in every woman. *$34.95 list, 8.5x11, 128p, 270 color images, index, order no. 1897.*

Professional Commercial Photography
Lou Jacobs Jr.

Insights from ten top commercial photographers make reading this book like taking ten master classes—without having to leave the comfort of your living room! *$34.95 list, 8.5x11, 128p, 160 color images, index, order no. 2006.*

Professional Wedding Photography
Lou Jacobs Jr.

Jacobs explores techniques and images from over a dozen top wedding photographers in this revealing book, taking you into the minds of the masters. $34.95 list, 8.5x11, 128p, 175 color images, index, order no. 2004.

The Art of Children's Portrait Photography
Tamara Lackey

Create images that are focused on emotion, relationships, and storytelling. Lackey shows you how to engage children, conduct fun sessions, and deliver timeless images. *$34.95 list, 8.5x11, 128p, 240 color images, index, order no. 1870.*

Sculpting with Light
Allison Earnest

Learn how to design the lighting effect that will best flatter your subject. Studio and location lighting setups are covered in detail with an assortment of helpful variations provided for each shot. *$34.95 list, 8.5x11, 128p, 175 color images, diagrams, index, order no. 1867.*

Step-by-Step Wedding Photography
Damon Tucci

Deliver the images that your clients demand with the tips in this essential book. Tucci shows you how to become more creative, more efficient, and more successful. *$34.95 list, 8.5x11, 128p, 175 color images, index, order no. 1868.*